LOST
CIRENCESTER

ROBERT HEAVEN

AMBERLEY

First published 2021

Amberley Publishing
The Hill, Stroud
Gloucestershire, GL5 4EP

www.amberley-books.com

British Library Cataloguing in Publication Data.

A catalogue record for this book is available from the British Library.

ISBN 978 1 4456 9886 1 (print)
ISBN 978 1 4456 9887 8 (ebook)

Origination by Amberley Publishing.
Printed in the UK.

Contents

Acknowledgements 4

Introduction 5

1 Around Town 6

2 Shopping 11

3 Getting Around 37

4 Places of Worship 54

5 Houses 60

6 Hospitals 63

7 Places 68

8 Amusements 71

9 Local Characters 88

10 About the Author 96

Acknowledgments

Most of the photographs in this book are from my own collection and press images and other material granted to me by editors of the *Wilts & Gloucestershire Standard*, John Wilson and Tamash Lal. I am particularly appreciative of the images used that were taken by the *Wilts & Glos Standard* photographers Paul Stallard, Graham Light, Chris Bowler et al. My thanks go to James Harris, the curator at the Corinium Museum, for kindly allowing me access to the museum's collection of photographs and for his advice regarding provenance. Other images are from Cirencester Open-air Pool Association. My thanks to David Viner at the Bingham Library Trust for his wise advice; Linda Edwards, matron of Cirencester Hospital, for providing access to the Cowper painting used herein and Teri and Patrick Walsh for provenance and permissions for the same; Judith Wood, founder of Phoenix Majorettes; and Rachael Jefferies for information and archival material for the Jefferies family. I am indebted to the members of the OldCiren group on social media for family and personal photographs and the memories shared of the activities, associations and the clubs that once held the community together in the good times as well as the bad. In this book I have tried to avoid what has been written previously or using photographs that have been used before. There are already a number of different published histories of Cirencester, its pubs and changes to streets and buildings in the last century that I acknowledge as valuable secondary sources, which have informed but have not been intentionally replicated herein.

Introduction

Lost Cirencester is a visual guide though the last 100 years or so of the town's history – a snapshot of life as it once was before and after the wars. It includes buildings and streets that were once there; places of recreation and worship; parks that have evolved to what they are today; and activities that were at one time popular, but which today few can remember. This book provides a reminder of the carnivals and circus that once enthralled the people of Cirencester and an insight into the lesser-known activities such as the servicing of Spitfire and Hurricane aircraft right up until the 1970s by townsfolk.

Lost Cirencester invites the reader to step back in time to the days before supermarkets, when everything had to be bought at a counter in the town shops; times when the cinema did more than just show films; and time when there were diving competitions and water polo at the open-air pool. There are reminders of trips by railway and the stations and 'halts' that are now buried beneath the ring road and other developments of the 1970s.

This book is not about the Roman heritage that continues to draw thousands of visitors to Cirencester each year. This book is about what no longer exists to be seen or enjoyed in Cirencester; things, buildings and people that remain only in the memories of an ever-decreasing local population as they 'Cross over the Churn', their demise marked only by mention in the *Wilts & Glos Standard*'s family announcements page and an eventual memorial stone at Chesterton or Stratton Cemetery.

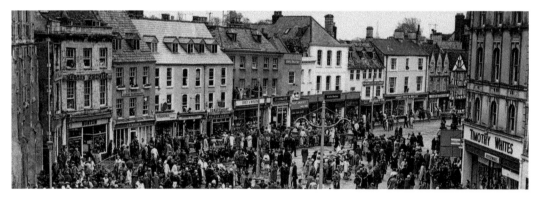

Market Place, 1960s (W&GS)

It goes without saying that much has changed since the Romans left Cirencester around AD 400. While the buildings and premises have constantly evolved and continue to do so to this day, much of the layout of the roads and streets the Romans established remain largely unchanged – other than the parts of roads and streets that were built over by the construction of the ring road in the 1970s.

The ring road significantly changed the face of Cirencester and while planners would argue that much was gained, a great deal was also lost, along with other things that this book will attempt to document. What lies within is a 'snapshot' of some but not all that has ceased to exist.

Around Town

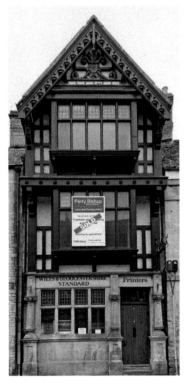

Wilts & Glos Standard Office, 1993

The *Standard* has been a regular feature in the lives of Cirencester people, providing local news and vital 'what's on' information. In Cirencester it has always been the go-to place to source gossip and scotch rumour about who's been in 'up in Court', died or got married.

Established in Malmesbury in 1837, the *Wilts & Glos Standard* newspaper moved to Cirencester in 1840. It was initially published from the proprietors home in Dyer Street, but in 1904 the new office was built at No. 74 Dyer Street. The *Wilts & Glos Standard* was lost to Cirencester gradually. The offices and the printing sheds remained in use until 1988 when they were demolished. The office fronting Dyer Street was sold in 2018.

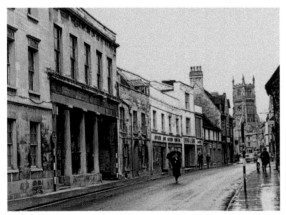

Dyer Street in the 1950s

The Dyer Street of today is very different to how our grandparents would have known it. The route remains the same, leading away from the marketplace towards the direction of the London Road, but many of the buildings have altered over time, especially in the 1960s and 1970s when buildings such as Ovens and Son's Furniture Dealers and the Congregational Church opposite it were knocked down as part of the Forum development. (Corinium Museum)

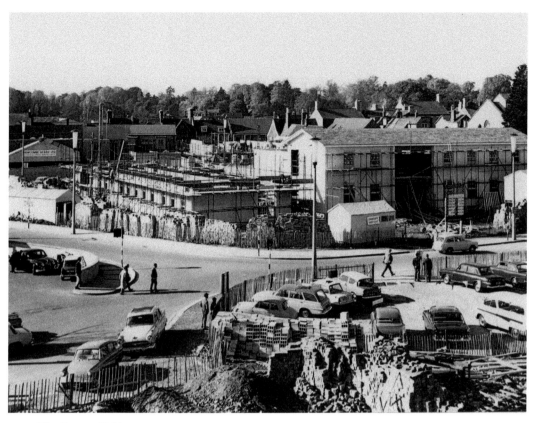

The Forum, 1964

During the 1960s many buildings and land was cleared to make way for the Forum car park, the new police station and a courthouse. The picture shows the view from the back of Ovens Furniture Store in Dyer Street (demolished).

The Forum has continued to evolve over the years since it was first developed and some of what was new in the 1960s and 70s has been repurposed or built over. The once new courthouse shown in the photo ceased being a court some time ago and has been recently purchased for a different use. (W&GS)

Cirencester Market Place

The marketplace has seen many changes over the last hundred years or so. Buildings have been demolished and streets adjoining it widened. The town hall, which connected to the parish church, has been cleaned a couple of times, invoking mixed feelings (including fury) among locals. The war memorial has had the iron railings removed that once surrounded the area to the front of the church.

The shops either side of the church have undergone many changes of use and ownership, a trend that continues to this day. Losses in the last Century include Trinder's Chemist, to the left of the war memorial; Hamper and Frys Tailors to the right of the town hall that later became another tailor's – Pakeman; further down that side of the marketplace Baily and Woods booksellers/stationers/printers; and the Dale Forty Piano showroom. Boultons, a sort of drapery department store, was taken over by Rackhams and by House of Fraser in 1975.

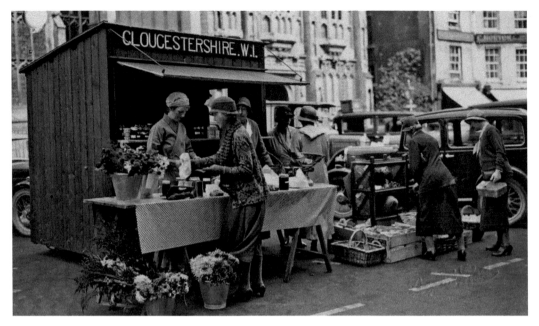

Women's Institute Stall, 1939

Cirencester marketplace has always been a popular place to shop, either in the actual shops or at the regular markets that have filled the central space for many centuries. The market, while not strictly lost has undergone many changes in the last few years, especially in the types of products, goods and food sold. The market stalls have changed over time in terms of what they sell. Today's offerings of many types of olives, artisan bread and Indian sweetmeats, etc. are quite different from even a few years previously when these would have been viewed as a little too exotic. (Corinium Museum)

Market Trade, 1986

Cirencester's Charter Markets are held on Mondays and Fridays. One of the oldest in the country, it is mentioned in the Domesday Book in 1086. (W&GS)

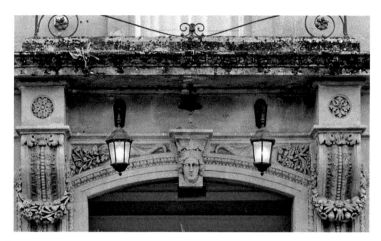

Corn Hall

In 1977 the Tourist Information Agency moved from just inside the Corn Hall entrance to the Corinium Museum on Park Street. The photo shows the move but in the background can be seen the former narrow alleyway before it was transformed in 2008 at a cost of £2 million. It is now a thriving arcade of shops and purveyors of high-end comestibles including Made by Bob.

The Corn Hall opened in 1863 with a main hall and additional rooms included a reading Room and library, school of art, business offices, and rooms for the hall keeper. A number of changes have been carried out over time. In 1951 several rooms were converted into additional commercial premises and rented out to local firms as office space. The main hall itself was leased as the Civil Defence Headquarters for the town.

In the 1960s and 1970s, there was a lift just inside the main entrance that took members to the top floor of the Corn Hall to the RAFA club – a social club/bar that closed down in the 1970s and has been replaced by several different ventures over the years including a restaurant named The Eagles Nest.

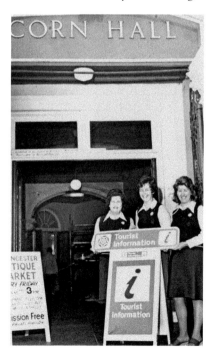

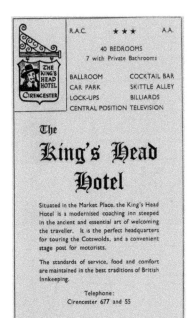

King's Head Hotel

Advert for the King's Head, *c.* 1964, pre-STD phone numbers. The historic fourteenth-century King's Head Hotel, adjoining the Corn Hall, has also been radically transformed in recent years. Many people remember it as being a rather shabby hotel, past its heyday as an upmarket place of choice for dinners, balls and formal functions.

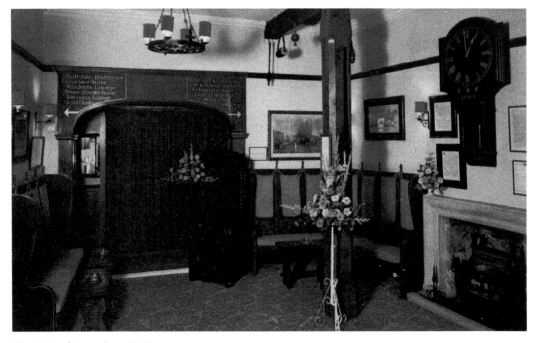

King's Head Reception, 1960s

The hotel closed in 2007 but reopened in 2014 having had £7 million spent on removing walls, creating new spaces and facilities and transforming the dark and dingy alleyway that led to the Corn Hall. Before the transformation the alleyway had a small tobacconist kiosk that sold gifts, as well as cigarettes.

For many years there was a stagecoach on display at the rear of the Corn Hall. Although generally accepted as being the original relic of times past when the King's Head was a coaching inn, it was popular with visitors to the town who did imagine it to be original. A replica can be found in the large car park area at the Highwayman Inn, Elkstone.

Shopping

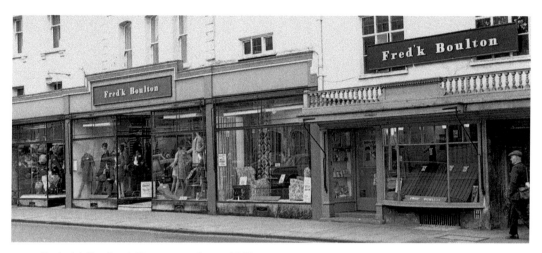

Frederick Boulton's Department Store, 1967

Over time, many shops have changed in ownership and what they sell. Family firms such as Sidney Boulton in the marketplace from 1881 have been replaced: Boulton's became Rackhams in 1975, then House of Fraser until 2019, and is now empty (2020).

In its heyday Boulton's sold all manner of drapery items, clothes and soft furnishings. It also held regular fashion shows that attracted many Cirencester women who were searching for that special bonnet or the winter coats that Boulton's specialised in. Fashion-conscious men could buy the latest jackets for hunting and for underneath – pure wool vests with matching pants for 3 shillings and sixpence (in 1912). (WG&S)

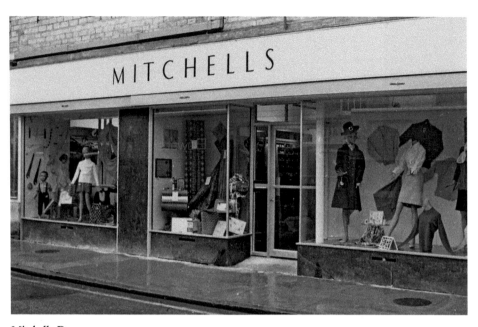

Mitchells Drapers

Mitchells Drapers, Castle Street, in 1967, which is now Holmes Opticians. (W&GS)

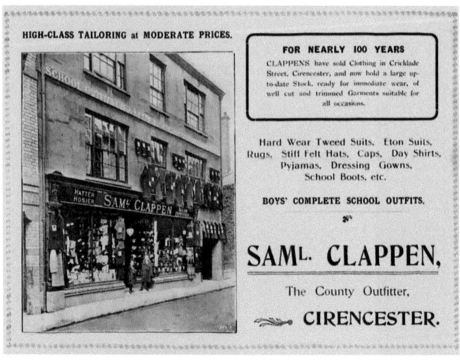

HIGH-CLASS TAILORING at MODERATE PRICES.

FOR NEARLY 100 YEARS

CLAPPENS have sold Clothing in Cricklade Street, Cirencester, and now hold a large up-to-date Stock, ready for immediate wear, of well cut and trimmed Garments suitable for all occasions.

Hard Wear Tweed Suits, Eton Suits, Rugs, Stiff Felt Hats, Caps, Day Shirts, Pyjamas, Dressing Gowns, School Boots, etc.

BOYS' COMPLETE SCHOOL OUTFITS.

SAM^L. CLAPPEN,

The County Outfitter,

CIRENCESTER.

Advert for Clappen's

Clappen's in Cricklade Street (now occupied by Waterstones books) sold menswear and school uniforms. It was sold in 1982. French & Sons Ltd in Regent House, West Market Place, was another large drapers. It is now Phase 8 dress shop.

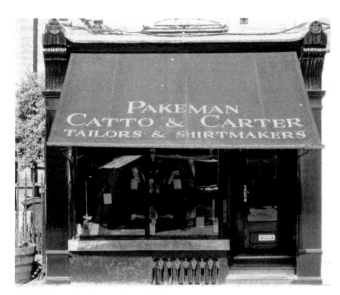

Pakeman, Catto & Carter

Pakeman, Catto & Carter, a tailors that vanished suddenly overnight in 2017, has been replaced in 2020 by Blushes, the fourth branch of a chain of beauty salons. A tailor shop of one form or another has stood on the site for many decades, previously being Hamper and Fry.

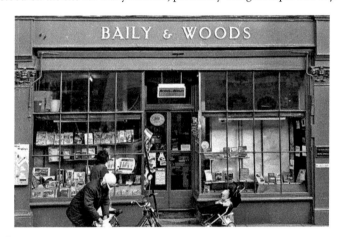

Baily & Woods

Further down from Pakeman's could once be found Baily and Woods booksellers/stationers/printers, which was established in Cirencester in 1839 (was Baily & Jones in 1850). Baily and Woods, listed in trade directories as newsagent, stationers, printers and booksellers, was, as the listing suggests, an Aladdin's cave of paper treasures – a long cavern of items from coloured paper, albums, glue and paper hinges to affix stamps and hole punches, an endless list of things to spend your pocket money on.

The newspapers, other than the local *Wilts & Glos Standard*, were brought to Cirencester from London by train each day. However, other shops also sold them. Some changed hands or closed over time but listed in 1941 are W.H. Smiths in Castle Street, Burtons and Callows that were once in Gosditch Street, Trinders in Castle Street, S. Dike in Cricklade Street, A. J. Petrie also in Cricklade Street but sold only Sunday newspapers, W. Poulton in the West Market Place and W. Waite in Dyer Street. (W&GS)

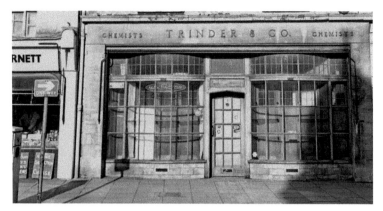

Trinders Chemist, Market Place

Trinders the chemist was run by Mr Brooks from the 1940s up until he died in 1972. It later became Woodcocks Wines and Spirits and more recently an exotic rug shop. (W&GS)

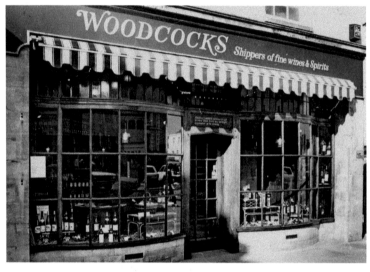

Woodcocks Wines and Spirits

Woodcocks Wine shop occupied Trinders for several years after 1972. (W&GS)

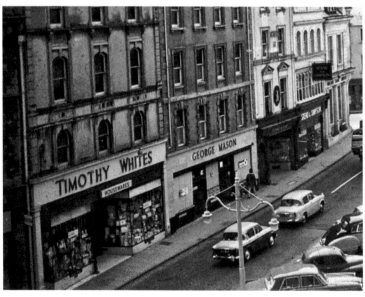

Timothy Whites & Taylors Chemists

Established in 1928, Timothy Whites & Taylors Chemists once occupied the premises currently taken by Santander in the Market Place and sold household goods that would be delivered, but only as long as the items would fit into the wicker basket on the delivery bike. (W&GS)

Grocers

Notwithstanding today's tasty treats from stalls in the marketplace at the Monday and Friday Charter markets, it has always been possible to buy comestibles in the shops within walking distance of the marketplace.

Grocers included Gifford & Groves in the marketplace, International Stores at the top of Cricklade Street, Legg's in Dollar Street, Liptons in Cricklade Street, Mason and Gillet's in West Market Place, Parry & Son in the marketplace, and Trotman's and Walker & Co., both in Castle Street.

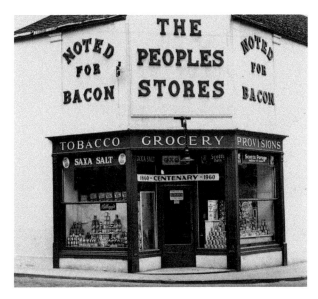

People's Stores, 1955 and 2020

The People's Stores stood in Gosditch Street on the corner with Thomas street from 1860–1960. It was one of several grocers in that part of the town.

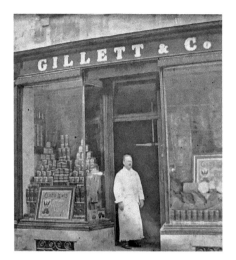
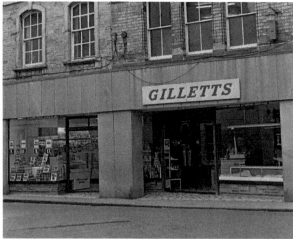

Gilletts Groceries, Black Jack Street, 1920 and 1971

In the 1970s, delicatessens first appeared in Cirencester in the marketplace, although many of the products they sold continued to also be sold by the town's grocers such as Gilletts in Black Jack Street, which had been there for decades before. (W&GS)

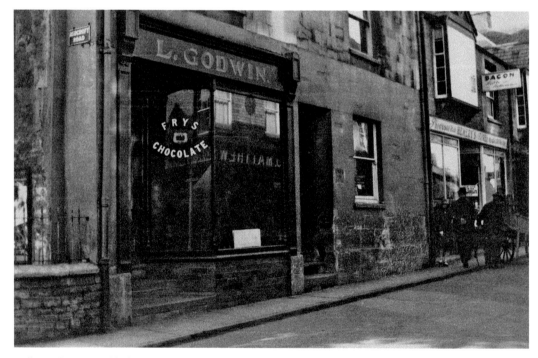

Lolly Godwins, Cricklade Street, 1920

In the 1940s, at what was then No. 20 Cricklade Street, on the corner with Ashcroft Road, was a shop that sold 'Fancy Repositories'. The shop was owned by Mrs Godwin – known locally as 'Lolly' Godwin – and at the time 'Fancy Repositories' meant all sorts of craftwork – patterns, wool and such like. Judging by the window notice on the photograph taken in the 1920s 'Fancy' also referred to chocolate.

Lolly Godwins shop no longer exists and the site was redeveloped after the war. Wheelers stores occupied the site from the 1950s to 1976. (Corinium Museum)

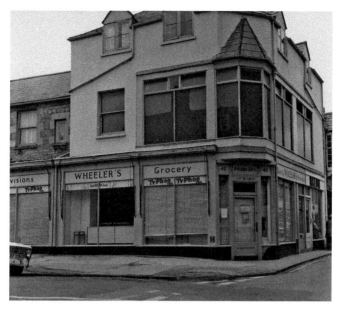

Wheelers Stores, 1976

When I was a boy, growing up in the 1950s and 1960s, my mother used go into town several times a week to do her shopping. Shops such as Wheelers stores grocers had proper counters with a stool to sit on while you gave the assistant your order. The order would be itemised by the assistant on a handwritten receipt and payment would usually be made at the time of the order in cash. Few people had a chequebook in the 1950s and 1960s and until direct bank transfers, most working people were paid weekly in cash, the money being handed to the employee in a brown envelope with a window in it to allow the edge of the notes within to be counted before the seal was broken. (W&GS)

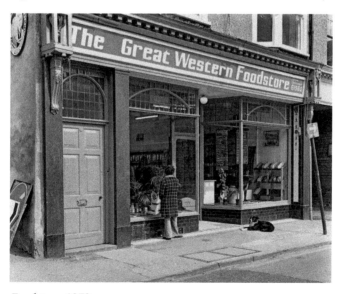

Great Western Foodstore, 1979

The Great Western Foodstore was opposite Wheelers for a while after it had closed. The store sold 'Wholefood'. The business was dissolved in 2014 and the shop now sells pre-made meals by the name of 'Cook'. (W&GS)

Butchers

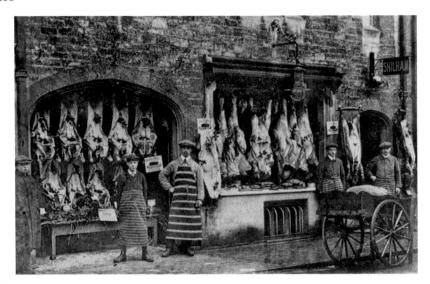

Shilhams

Shilhams Butchers in Cricklade Street, *c*. 1932. Cricklade Street has had a number of different butchers during the last century including Thomas Shilhams Family Butchers and Dewhurst, which closed in 1995. Thomas Shilham Sr bought the lease for his shop at No. 21 Cricklade Street from Edwin Peckham in 1911 and the Shilham family ran it until 1984, after which it was demolished as part of the redevelopments in Cricklade Street. Butchers have come and gone in Cirencester over the last hundred years, and few remain other than Jessie Smiths in Black Jack Street. (OldCiren)

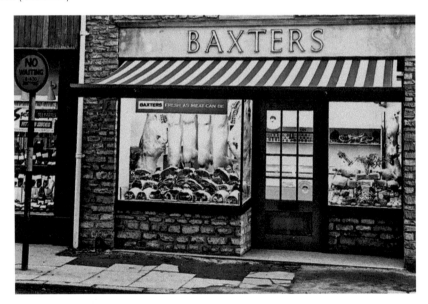

Baxters Butchers

Baxters Butchers in 1965. It once had a branch in Market Place and later in Castle Street where the Cancer Research shop is today.

A more recent loss is Chesterton Farm Shop, which closed in 2014.

Other than the London Central Meat Company Ltd in Market Place and Baxter's for a while, butchers were mainly located in the streets leading off Market Place with some further afield in Watermoor. In 1940 the following butchers sold fresh meat in Cirencester: W. Burge, Eastman Ltd and McWilliam & Son in Cricklade Street; Shilham and H. Leeson in Ashcroft Road leading off Cricklade Street; A. Fox and F. H. Hannis in Gloucester Street/Gosditch Sreet; Jessie Smiths was in Black Jack Street where the remain today; F. Walden was in Dyer Street; and at Watermoor there was G. Arthurs and P. Humphrey.

Four Seasons Butchers in the Woolmarket opened in 2019 and then went into liquidation a few months later in November 2019. Others in recent years have included Dewhurst in Cricklade Street, which was part of a chain that was eventually disbanded in 1995 in the face of increasing supermarket competition.

Shops usually only had a centrally placed single cash till, which worked well for smaller shops such as Jessie Smiths the Butchers in Black Jack Street. However, larger shops such as Boulton's in Market Place or French & Sons in West Market Place had different needs. French & Sons had a sort of overhead system comprising a taut wire that ran from the sales desk to the cashier's station, which was an out-of-sight caged boot somewhere else in the shop. The sales assistant would put the customers' money into a cannister attached to the wire and by tugging firmly on a spring-loaded lever, the canister would be catapulted along the wire, reaching its destination in mere seconds. The cashier could then 'return fire' with the change and a receipt.

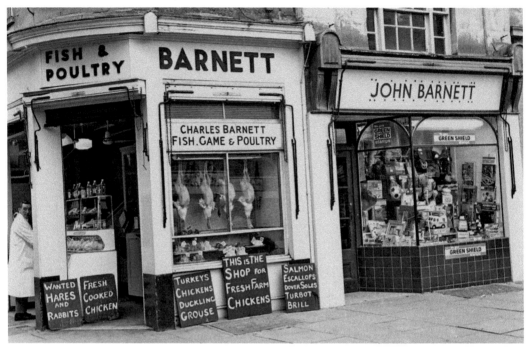

Chas Barnetts Shop, West Market Place, 1967

Many Ciren people will remember the Charlie Barnett fish and game shop that once occupied the corner of West Market Place. Barnett also owned the part next to his fish shop, which became the London Meat Co. for a while and later Baxters Butchers. Charlie Barnett came from a well-known Gloucestershire cricketing family. He was regarded as one of the most stylish batsman of the 1930s. He died in 1983 aged eighty-two. (W&GS)

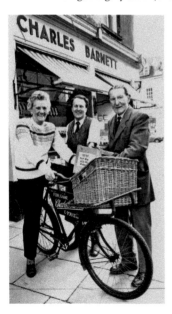

Chas Barnett and Nancy Rogers on a Delivery Bike

Charles Barnett used a delivery bike, which was ridden for forty years by Mrs Nancy Rogers. Barnett's was once the shop to buy hard-to-find comestibles such as hare, rabbits and grouse. Latterly it has gone 'east' and sold clothes. It is now an estate agent. (W&GS)

Even small local businesses such as Jack Arnold at the Beeches Stores employed a 'lad' to ride a 'butcher's bike'. A butcher's bike was typically a heavy steel-framed bicycle with a basket or storage box mounted within a framework which was fixed to the frame (not the fork) of the bike. Often, they would also feature a sign advertising the business concerned, which would be attached within the main triangle of the bicycle frame. Their popularity declined significantly towards the end of the 1950s with the increase of motorised transport.

Macfisheries, 1970s

Macfisheries founded by Lord Leverhulme at the end of the First World War, was a national retail fishmonger chain that served Cirencester housewives right through the war years and up until April 1979. Due to a sell out to International Stores, all the wet fish shops were simply closed down within three months.

Macfisheries Fish and Game Co., around 150 yards from Barnett's down in Cricklade Street, was listed in the Baily & Woods directory of 1940 with a telephone number of Cirencester '72', but did not deliver. (Corinium Museum)

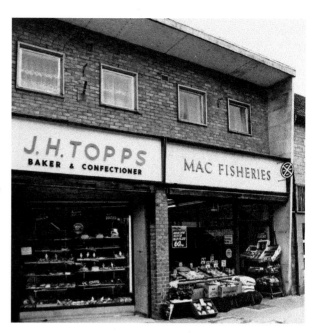

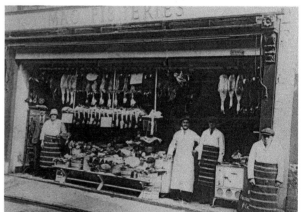

Macfisheries, 1930s.

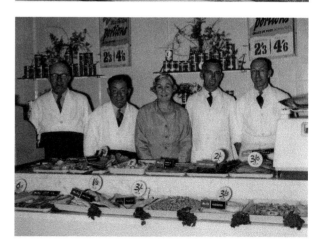

Macfisheries, 1970s.

21

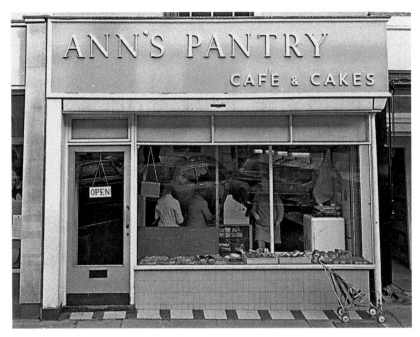

Ann's Pantry, 1974

Ann's Pantry, affectionally known locally as 'Ann's Panties', in the Market Place is now a multi-vendor antiques shop that once served teas, and sold bread and fancy cakes. (W&GS)

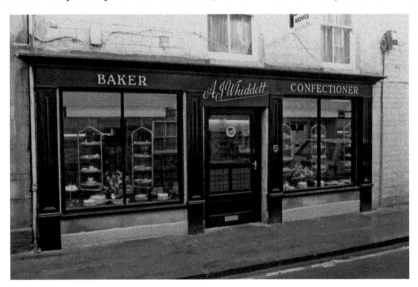

Whiddetts, Gosditch Street

Before supermarkets and additives that somehow 'preserve' bread for weeks, most people bought bread if not daily, then several times a week. Bread had to be fresh and also had a short shelf life. Cirencester once had seventeen different bakers to meet this demand. Whiddetts is one example, which closed in 2019 after fifty-right years in business.

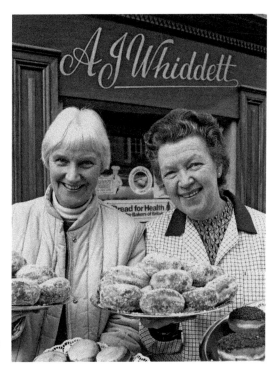

Mays Bakers

Bread once came in quite basic forms and types: bread produced by the town's bakers was mainly 'tin', 'cob' and 'split'. Sliced bread had been introduced to the UK from the USA in 1937, but Ciren folk usually bought bread unsliced.

Part of the Blue Door Tearoom in Dyers Street, Mays Bakers closed in 1988. It was a commercial catering company for several years after supplying weddings but it is now Leightons Opticans. (W&GS)

Whidetts, 1994

Most bakers and confectioners had specialisms: the Blue Door in Dyer Street sold 'cream horns' and 'lions ice cream cakes' at Christmas; Herberts in Market Place sold 'chocolate chessboards'; Viners, now named Halls, in Castle Street specialised in lardy cakes! They had a rival, Topps in Cricklade Street, who also sold lardy cakes and some folk to this day swear they were the best. (W&GS)

Lardy Cakes from Halls, Castle Street, 2020

Lardy cake is a traditional English rich spiced form of bread and although it's found in several southern counties of England, Ciren being Ciren, the locals have always claimed lardy cake to be a local delicacy. I'm not sure the term delicacy is actually the correct description for the Ciren version. As Elizabeth David puts it in her book *English Bread and Yeast Cookery* (1994), 'How could they be lardy cakes without lard?'

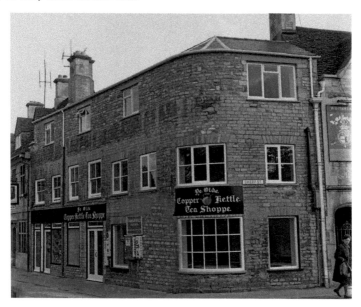

Copper Kettle, Castle Street, 1971

The Copper Kettle at the bottom end of Castle Street served delicate sandwiches and cakes such as 'French Fancies', which were a sickly sweet fondant covered sponge in rather garish colours. (W&GS)

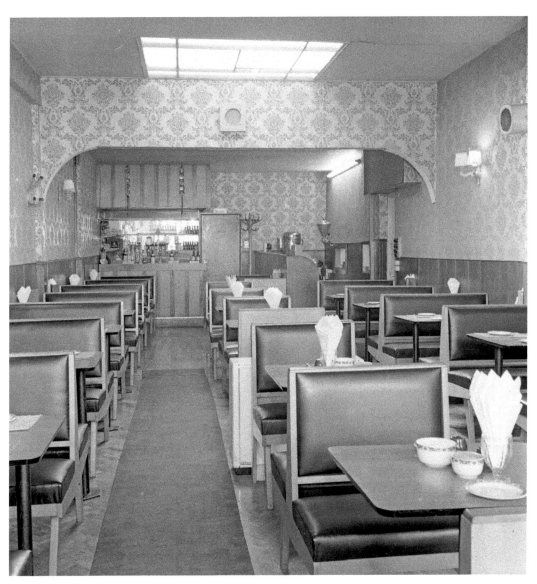

Castle Grill

In the 1950s and 1960s more people drank tea than coffee, but you could get coffee at the Mad Hatter and the Castle Grill directly opposite. The Castle Grill had two sides: one the 'posh' side and the other side a coffee bar with a juke box, frequented in the 1960s by Cirencester's version of motorcycling 'Rockers'. 'Mods' preferred the Mad Hatter opposite.

Watermoor Café, 1960s

There were many cafés in Cirencester to drop into for a quick cuppa or a mug if you ventured into some of the smaller cafés, affectionately known as 'greasy spoons'. The café shown here on Watermoor Road had many name changes over time including the Cherry Tree Café, Cottage of Content and, in the 1950s, the rather more exotic name Café Caribbean, which was favoured by the RAF officer cadets from RAF South Cerney. One owner kept sa green parrot on a perch by the counter. The cafe closed many years ago and is now a Chinese takeaway. The Treasure Trove junk shop that used to be next door is now a tattooist. (Corinium Museum)

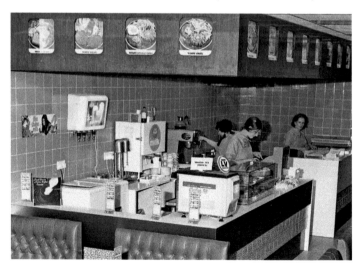

Wimpy Bar, Dyer Street, 1972

The Wimpy Bar was one of many premises that were built on the site formerly occupied by the Congregational Church in Dyer Street.

Castle Street, 1978

Castle Street, looking towards the church with Castle Grill on the right and the Mad Hatter on the left. (Corinium Museum)

Paramount Restaurant, 1967

The Paramount Chinese restaurant opened to great fanfare in the late 1960s in what used to be F. J. Huck's Corn Stores in Castle Street. It is now the Asia Lounge, having been Tatyans. The Paramount was the first non-traditionally British food outlet in Cirencester and it was extremely popular, not the least for the novelty of the red flock wallpaper, but also for being able to try to eat what was regarded as 'foreign food' with chop sticks. Huck's, which it replaced, was a large shop with bare wooden floorboards and a long counter. All around were huge open bags of different grains and animal feed for sample handfuls to be taken, examined and sniffed at. (Corinium Museum)

There's been a resurgence in the last decade of old-style sweet shops, with new shops such as the Candy-Man opening in Black Jack Street in 2013, but before this new interest in 'gob-stoppers' 'aniseed balls' and 'pinapple chunks', sweet shops had generally gone out of fashion. This was probably due to the supermarkets, which had made it easy to buy pre-packed sweets as people queued for the tills with their baskets full of other shopping.

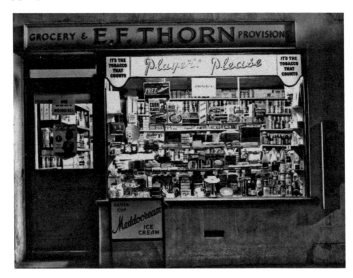

Mrs Thorn's Dyer Street, 1960s

Cirencester once had many sweet shops and places to buy pre-wrapped bars of confectionary and sweets, which were weighed out at the shop counter. Thorn's in Dyer Street, which closed in the late 1960s, sold sweets, tobacco and a variety of ice cream called 'Meddocream', which was made in Birmingham from Wiltshire milk collected at the Co-Operative Wholesale Society Creamery at Latton (closed in 1996).

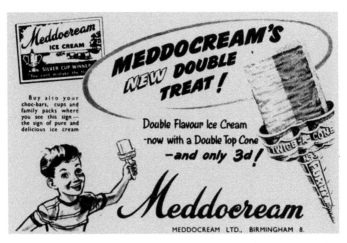

Who can remember Lanham's sweet shop just 100 yards from Thorn's on London Road, which closed many years ago? It is now the Old Brewery Guest House.

Woolworths Pick 'n' Mix, 1967

Woolworths in Cricklade Street managed to hang onto something of the past until its closure in late 2008, selling sweets by weight from a huge range, while embracing the modern way of self-selection – the ever-popular pick 'n' mix. There's been a resurgence of interest in the last decade of old-style sweet shops selling traditional loose sweets by weight from a bright array of glass bottles on shelves behind a counter.

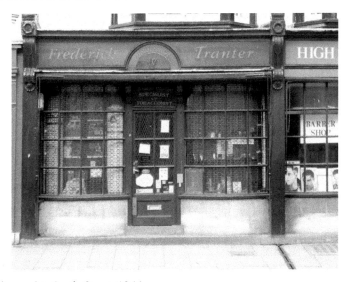

Tranters Tobacconist, Castle Street, 1966

Frederick Tranter at 'the Pipe Shop', No. 7 Castle Street, sold tobacco in large and small packets drawn much like sweets from large tins in the shop. Cirencester had many places to buy tobacco products including the Regal cinema and the Gaumont Picture House on London Road. All pubs sold cigarettes either over the bar or from a vending machine in the pub or an alleyway outside. When the Second World War started in 1939, there were nine tobacconists in an area of a square mile around the marketplace.

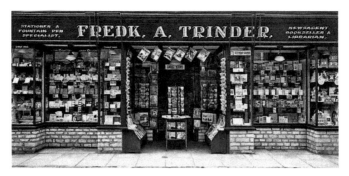

Trinders Stationers, Castle Street, 1960s

Trinders, at the bottom of Castle Street, was similar to Baily & Woods, but sold some items that were exclusive to the shop such as polythene bags of mixed-used foreign stamps. The bags could be bought in different sizes from around a shilling for a small bag to the princely 5 shillings for a big bag. (W&GS)

Cirencester Pipe Smokers Club, 1984

Cirencester Pipe Smokers Club once hosted pipe smoking competitions for men and women. Pipe smoking was a very popular hobby and even now, although largely outlawed, who can resist the pleasure of smelling a pipe of fine tobacco – Balkan Sobranie? (W&GS)

Winsons Newsagents, Watermoor, 1974

Other than local newspapers such as the *Wilts & Glos Standard*, newspapers were once brought daily to Cirencester from London by train. On arrival they were delivered to newsagents such as Baily & Woods in Market Place, Trinders in Castle Street, or W.H. Smiths – still there but mostly lost to the post office!

Toy Shops

There have been a number of shops that sold toys in Cirencester during the post-war period. Up until their closure in the 1960s onwards, toys could be bought in Woolworths, Baileys, Listers on London Road and Currys.

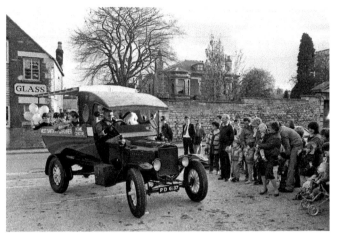

Baileys

Santa's visits were much-heralded events in Cirencester. In 1939 he arrived at Cirencester town station on the 2.38 p.m. train from London and was greeted by the Ciren Silver Band. After being paraded firstly to the Gaumont Picture House on the corner of Victoria Lane and London Road, he was then enthroned in his grotto at Baileys for the duration. In 1953 he seems to have caught an earlier train and it was simply announced in the *Standard* that he would be in the store from 2.15 p.m. on 28 November.

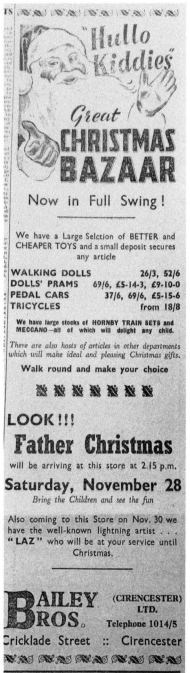

"Hullo Kiddies"

Great

CHRISTMAS BAZAAR

Now in Full Swing!

We have a Large Selection of BETTER and CHEAPER TOYS and a small deposit secures any article

WALKING DOLLS	26/3, 52/6
DOLLS' PRAMS	69/6, £5-14-3, £9-10-0
PEDAL CARS	37/6, 69/6, £5-15-6
TRICYCLES	from 18/8

We have large stocks of HORNBY TRAIN SETS and MECCANO—all of which will delight any child.

There are also hosts of articles in other departments which will make ideal and pleasing Christmas gifts.

Walk round and make your choice

LOOK!!!
Father Christmas
will be arriving at this store at 2.15 p.m.
Saturday, November 28
Bring the Children and see the fun

Also coming to this Store on Nov. 30 we have the well-known lightning artist . . . "LAZ" who will be at your service until Christmas.

BAILEY BROS.
(CIRENCESTER) LTD.
Telephone 1014/5

Cricklade Street :: Cirencester

Co-op Departments Store, Formerly Bailey's, Cricklade Street

Bailey & Co. in Cricklade Street was a 1920s building that occupied the site where Bishop's Walk is today. It was a large department store with (it was claimed) as many departments as the big London stores. Bailey's sold furniture, home fittings, menswear, electrical goods and had a toy department that Santa would visit each December. It later became a Co-op department store. (Corinium Museum)

Hardware

Before Gardiners Home Stores, which replaced what used to be Steels Garage at the bottom end of Dyer Street, ironmongery, hardware and much the same products sold by Gardiners today could be bought in a number of different shops in Cirencester.

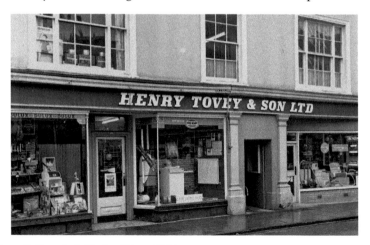

Henry Tovey & Sons Ltd, Market Place, 1974

Tovey's ironmongers was next to Boulton's in Market Place and closed in 1976. The proprietor Henry Tovey also owned a garage next to the shop that eventually became Grove Garage. Long since gone, the land it stood on now is occupied and extended by the Fleece Hotel. (Corinium Museum)

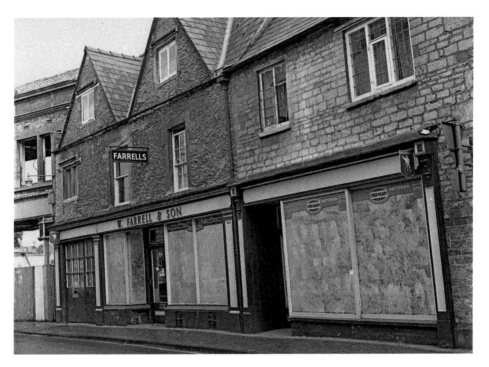

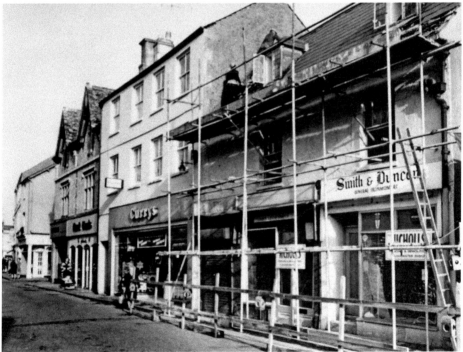

Farrell Bros, Castle Street, and Smith and Duncan, Cricklade Street

Now all lost to time, ironmongers in Cirencester once included Farrell Bros in Castle Street, Gillmans in Black Jack Street, Listers on London Road, Aubrey Rees at the Whiteway, W. H. Jackson and Duncan and Smith on Cricklade Street. (Corinium Museum)

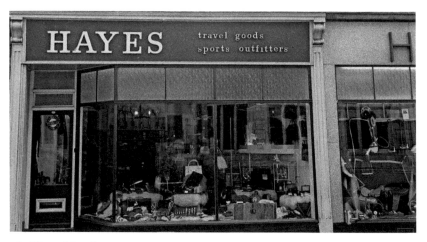

Hayes Saddle and Leather

Hayes Saddle and Leather shop was once to be found in Lower Market Place next to the Bear Inn. Hayes closed in 1984, having been there for more than half a century. Hayes Saddles still sell for high prices at auctions.

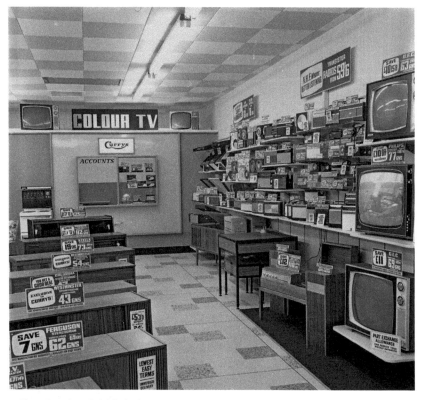

Currys Shop Interior, Cricklade Street, 1966

Several shops once served Cirencester for new cookers, toasters and televisions: Currys in Cricklade Street and the SEB (Southern Electricity Board), which also supplied electricity to the town. SEB hosted engaged couples' nights to promote the use of toasters and new cookers. (W&GS)

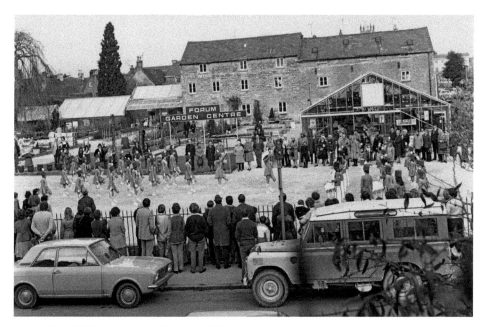

Reopening of Jefferies Garden Centre, 1980

Founded in 1795, John Jefferies and Sons became the Royal Nurseries and Seed Establishment in 1940. In that year, the firm had five nurseries in and around Cirencester including their first, on London Road. The main office at the corner of Castle Street and West Market Place, although long gone, is still affectionately known in the town as 'Jefferies Corner'. (W&GS)

Jefferies Royal Nurseries

Founded in 1795, the firm was based at the Royal Nurseries and Seed Establishment in Castle Street, while its seed warehouse (being used as flats in 1991) was in Tower Street and its nurseries were in Cirencester, Somerford Keynes and Siddington. In 1980 the firm opened the Kingsmeadow Garden Centre in Cirencester, and in 1985 the ownership of the firm and the management of the centre were taken over by Country Gardens PLC.

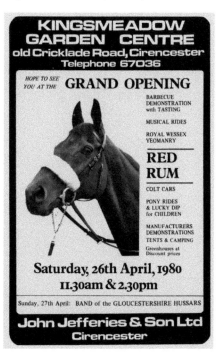

KINGSMEADOW GARDEN CENTRE
old Cricklade Road, Cirencester
Telephone 67036

HOPE TO SEE YOU AT THE **GRAND OPENING**

BARBECUE DEMONSTRATION with TASTING

MUSICAL RIDES

ROYAL WESSEX YEOMANRY

RED RUM

COLT CARS

PONY RIDES & LUCKY DIP for CHILDREN

MANUFACTURERS DEMONSTRATIONS
TENTS & CAMPING

Greenhouses at Discount prices

Saturday, 26th April, 1980
11.30am & 2.30pm

Sunday, 27th April: BAND of the GLOUCESTERSHIRE HUSSARS

John Jefferies & Son Ltd
Cirencester

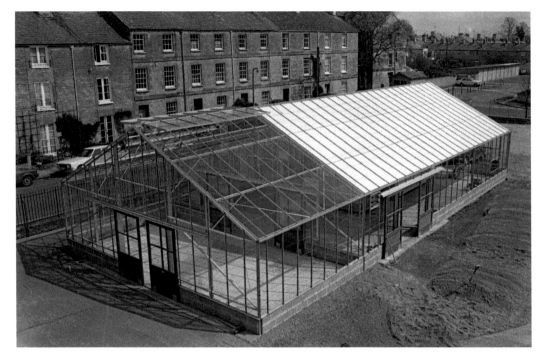

Jefferies Glasshouse, Corner of Tower Street, 1980

In 1980 Jefferies reopened a garden centre in Tower Street at its old seed warehouse. The Avenue Garden Centre closed in 1983 and is now a retirement housing development named after the old Jefferies family home, which formerly stood on the site, Mineva Villa. In 1980, the Jefferies family opened the Kings Meadow Garden Centre. Five years later in 1985 the ownership of the firm and the management of the centre were taken over by Country Gardens PLC. (W&GS)

Mineva Court on the same spot in 2020.

Getting Around

After the end of the Second World War, ownership of motor vehicles became more widespread. Prices dropped, second-hand vehicles became more available and manufacturers started to produce affordable cars and motorcycles.

Market Place, 1970

If you had car, or as many people had after the war, a motorcycle, it was once possible to park outside many Cirencester shops to collect shopping or just to pop in for a coffee somewhere. (W&GS)

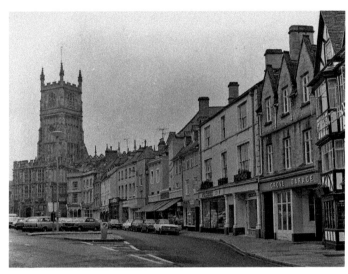

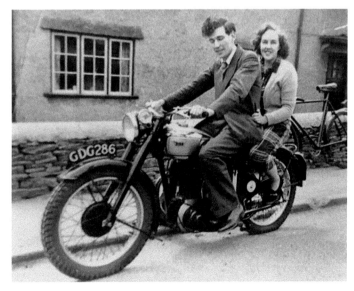

Couple on BSA motorcycle pre-helmet laws, 1958.

Garages

Motor vehicle engines in the 1950s and 1960s were not very efficient and even quite small cars or motorbikes were by today's standards 'petrol guzzlers'. This meant that there was a greater need to refuel more frequently than perhaps we have to do today and more garages existed with less distance between them.

Abbey Road Garage, 1950s.

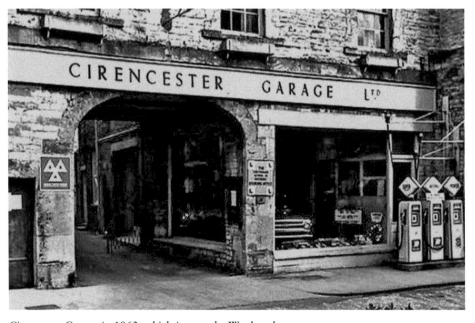

Cirencester Garage in 1963, which is now the Woolmarket.

Grove Garage (Formerly RC Chapel)

Established in 1930 by Harry Price, it was Grove Garage because of the proximity to Grove Lane. Grove Garage eventually moved to Market Place next to the Fleece.

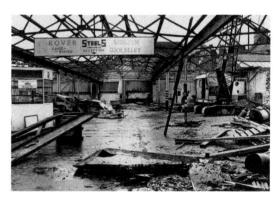

Steels Garage, Dyer Street

Cirencester garages also sold new and second-hand cars. Steels in Dyer Street were agents for new cars such as Wolseley, Austin and Rover, while Bridges Garages in Castle Street, which went out of business in 2008, sold rather more expensive vehicles such as limousines, landaulets and cabriolets. Cirencester Garage is now the Woolmarket and Steels was demolished in 1970 and is now Gardiners Homestore. (W&GS)

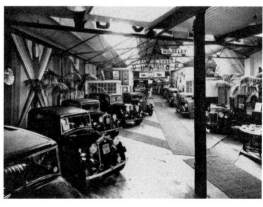

Ring Road

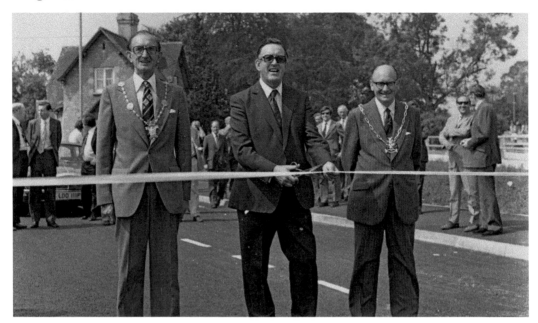

Official Opening of the Bypass, 1976

Every person who ever attended a school in Cirencester will know from lessons and visits to the Corinium Museum that Cirencester was built on the crossroads of two great Roman roads: the Fosse Way and Ermin Street. These still exist in some form, but have been built over and developed over time.

The biggest changes occurred in the 1970s, when the ring road was built around the town after nearly twenty years of planning. The A419 ring road opened in 1976. (W&GS)

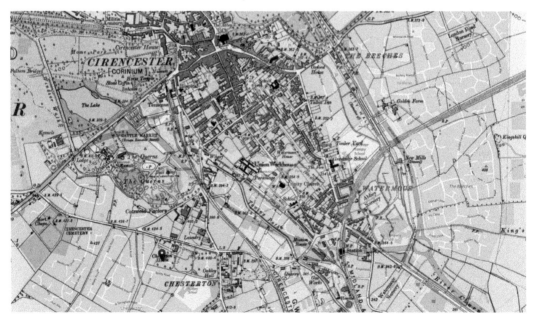

Bypass map.

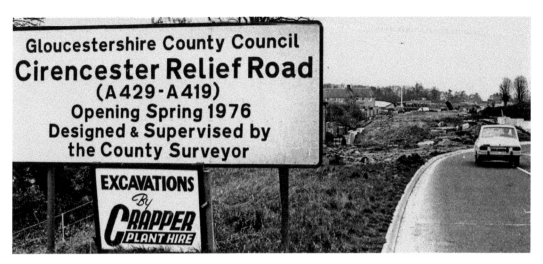

Bypass signpost, 1975. (W&GS)

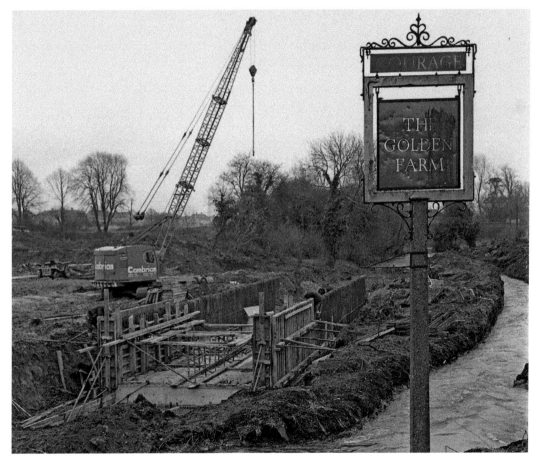

River Churn

The River Churn was diverted in 1974 at the end of Beeches Road and a new bridge was built a few meters from the old bridge to continue access to the estate. (W&GS)

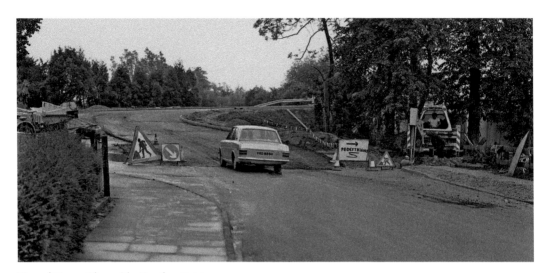

Top of Upper Churnside, Beeches Estate

This photograph shows the estate side of the bridge where a roundabout outside the Golden Farm pub joins Upper Churnside with Queen Elizabeth Road and the new bridge to Beeches Road.

As the ring road progressed, more and more parts of old Cirencester vanished as rivers and waterways were altered, bridges removed and streets demolished. Several areas of common land known to locals as Humpty Dumps were swallowed up by the new roads. One of these ran alongside the Churn, parallel to Beeches Road, and divided by Beeches Road from the actual estate. It was an overgrown stretch of wild grass, bushes and trees that was once the playground for local children and a shortcut to the Beeches estate. (W&GS)

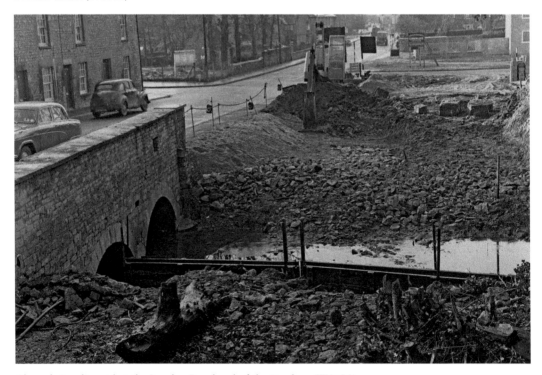

Churn being diveretd at the London Road end of the Beeches. (W&GS)

Watermoor Road Bridge, 1961

Watermoor was greatly changed by the new ring road, which cut a swathe of dual carriageway across the bottom end of Watermoor, dividing it from Chesterton to connect the A429 to the A419 Bristol Road. It wasn't just the ring road that changed things. (Corinium Museum)

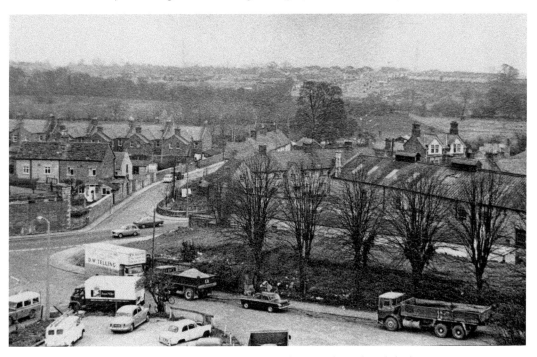

A look towards Watermoor Road, where the bridge has now been demolished. (Corinium Museum)

Watermoor Developments, 1960s and 1970s

Watermoor and other parts of the town were progressively developed from the 1960s onwards. Streets were demolished and new housing was built. Bridges were removed as the railways closed and roads were widened or diverted. Old housing and buildings were replaced and entire streets flattened to build new roads, housing and retail facilities at Watermoor during the 1970s.

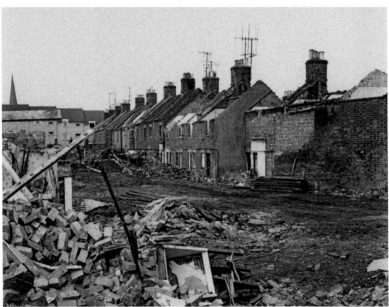

Stepstairs Lane, *c*. 1970, and Midland Road, *c*. 1970

Stepstairs Lane and Midland Road shown in the photographs bear little resemblance today to how they were pre-demolition in the 1970s. (W&GS)

Railways

Many changes were made during the 1970s with demolitions and new buildings in Dyer Street, the Forum, Cricklade Street and other parts of town. After the railway links to Cirencester closed in 1964 after the Dr Beeching Report, much of the land the railway had taken up was reclaimed slowly and then built on, thus rendering any hope of a present-day railway revival unlikely. Cirencester railway station was opened in 1841 and connected by a 5-mile-long single track to the main line at Kemble.

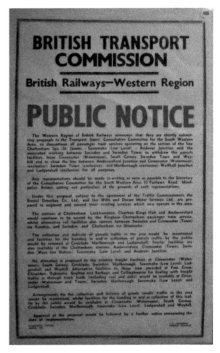

Railway closure sign.

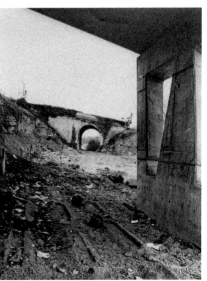

Towards Querns Hill Bridge, 1976

It's hard to see now where the railway tracks once were. Most of the old track lines have disappeared under new-builds and roads, leaving little trace of what were once arterial routes connecting Cirencester to the Midlands and further afield. (W&GS)

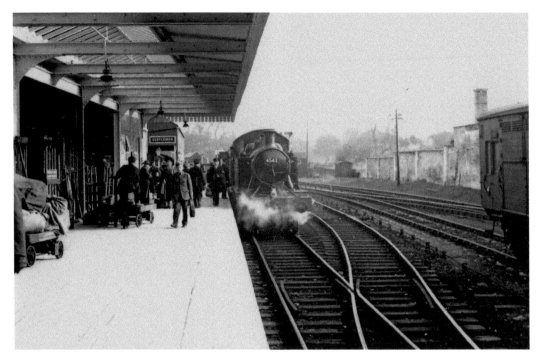

Cirencester Railway Station, *c.* 1953

Railway closure was threatened in the 1950s but to reduce costs and maintain the viability of the line, lightweight four-wheel diesel railbuses were introduced, which proved popular. Nevertheless the decline in business was inexorable, and the passenger service closed in 1964 to the great sadness of Ciren people, many of whom had sent sons off to wars from the platform, gone up to London for a visit to the circus, or just used it daily to get back and forth to work. (OldCiren/WGS)

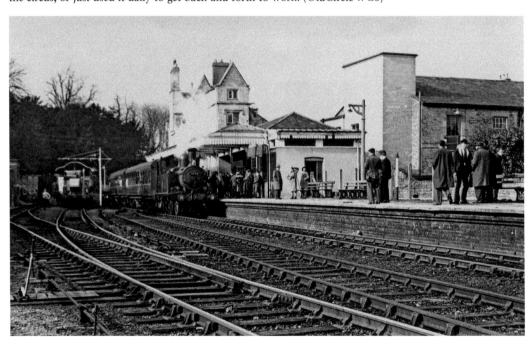

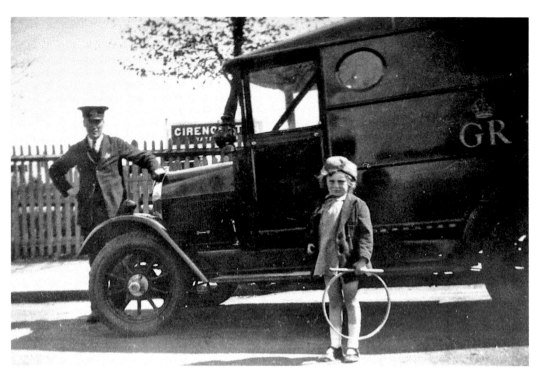

Unknown child in front of a mail wagon at the Cirencester town station, *c.* 1940. (OldCiren)

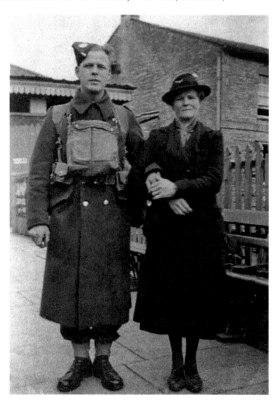

Elizabeth Heaven sees her son Fred off to war after leave in 1943.

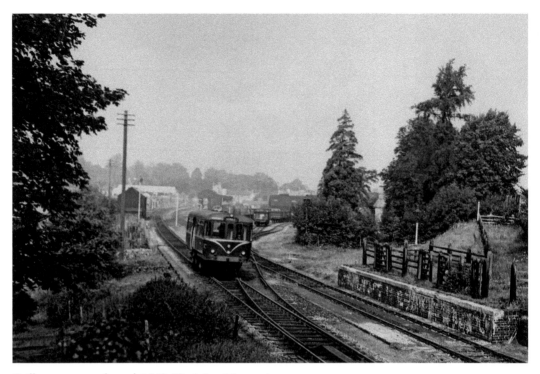

Railbus passes goods yard, 1963. (Corinium Museum)

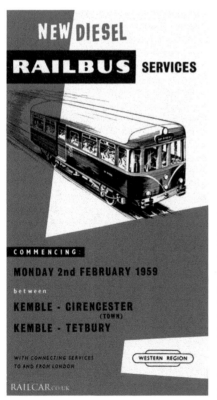

Advert for a Railbus, 1959

As a boy I remember well the steam trains chugging along the line at the back of our garden at Patterson Road, on their way to and from Fosse Cross from Watermoor. On hearing the train whistle as it crossed the City bank bridge I would often run to beat the train to the bridge at Queen Elizabeth Road to then hang as far as possible over the parapet to see down the chimney as it passed beneath. If I was feeling really brave, I would venture beneath to sit on the embankment and wave to the train driver through the billowing smoke and steam. One day the railway line was busy with several trains running through the Beeches estate and past our house. The next day nothing. It was the end of an era.

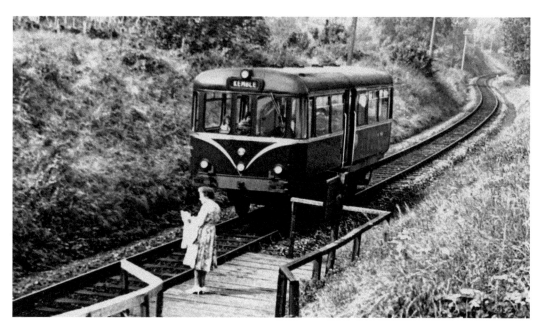

Chesterton Halt, 1960

There were several actual places to catch trains rather than at just the town station. There were halts at different places along the routes including Watermoor and Chesterton. The steps down to the Chesterton Halt are still there but the actual halt and railway are long gone. (Corinium Museum)

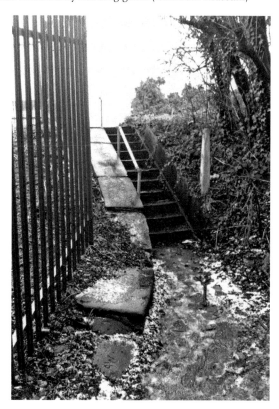

Steps down to Chesterton Halt today. (OldCiren)

Canals

Coal was delivered via barge from the Thames & Severn Canal via the 1.5-mile-long branch to the Cirencester Wharf, which was on the triangular piece of land at the end of the Sheep Street and Querns Hill junction.

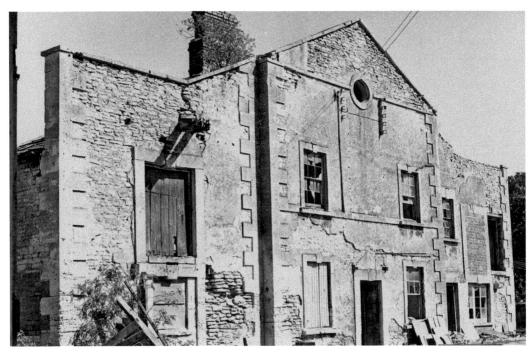

Old Wharf Building, 1975

The canal fell into a state of poor repair during the latter half of the nineteenth century and for a period of fifteen years from 1889 to 19 March 1904 there were no barges to Cirencester. This changed momentarily in 1904 when the *Gloucester Journal* reported that local coal merchant Frank Gegg & Co. had brought 37 tons of coal by barge direct from the colliery by waterway. (W&GS)

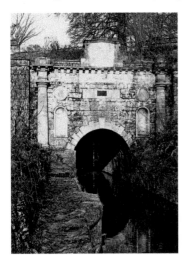

Canal at Coates, 1992.

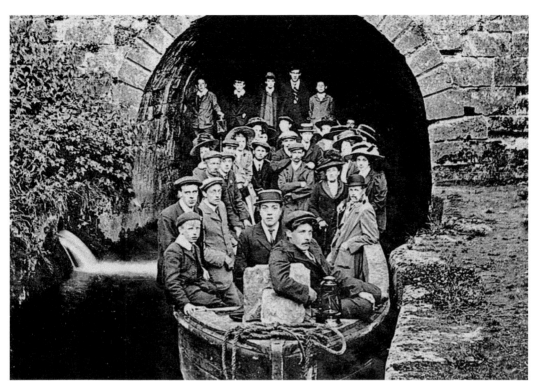

Canal tunnel at Sapperton, 1903.

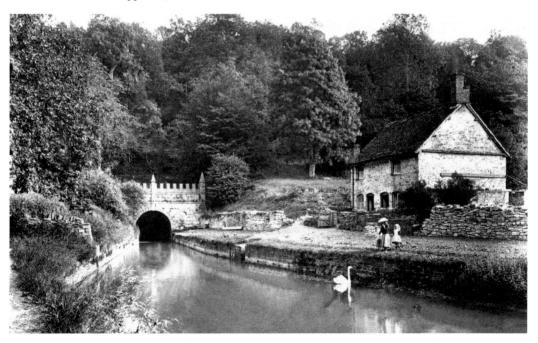

Canal at Sapperton showing the Daneway pub, 1930. Despite the plaudits by the press and local worthies who sought to use the canal for pleasure purposes, the Thames & Severn Canal was allowed to become derelict and was put up for sale in 1925. (WG&S)

Flying

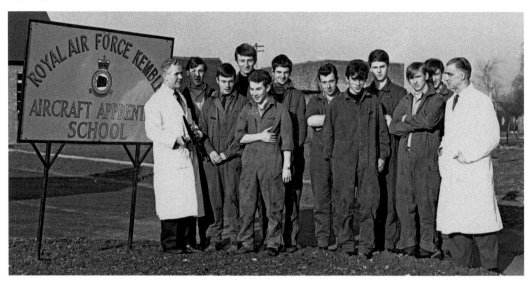

Apprentice Training at No. 5 MU, RAF Kemble

RAF Kemble employed many people over the years from its construction (1936–38) to its closure as an RAF unit in 1993. During the war years, Kemble was the headquarters for all the RAF Service Ferry Pools, coordinating this task with the civilian Air Transport Auxiliary (ATA) by distributing aircraft all over the country. In 1941 RAF Kemble turned out 2,300 aircraft of forty-one different types including 1,300 Hurricanes and 200 Beauforts – a total of 191.6 aircraft per month.

Not many people today can say they trained and worked on Spitfires, Hurricanes and other planes such as the Hawker Hunter and the Gloster Meteor, but many Ciren people did do this when the airport now called the Cotswold Airport was then the No. 5 Maintenance Unit for the RAF's collection of historical aircraft.

In 1941 RAF Kemble turned out 2,300 aircraft of forty-one different types including 1,300 Hurricanes and 200 Beauforts – a total of 191 aircraft a week. (W&GS)

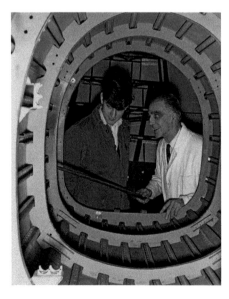

Apprentice training at No. 5 MU 1960s.

The Apprentice School at RAF Kemble was housed in a wartime hut to the edge of the airport, within walking distance of the hangers where apprentices were taught how to remove propellers and engines from Avro Shackletons and how to sew repair patches on Hurricane's wings (Hurricanes had wings covered in Irish linen fabric).

Apprentices learnt their craft on Spitfires, Hurricanes, the Gloster Meteor and a rare de Havilland Vampire jet, but were never let loose on the Folland Gnats that the Red Arrows flew from RAF Kemble from 1968 to 1983. The image shows an apprentice working on an historic aircraft in 1967. (W&GS)

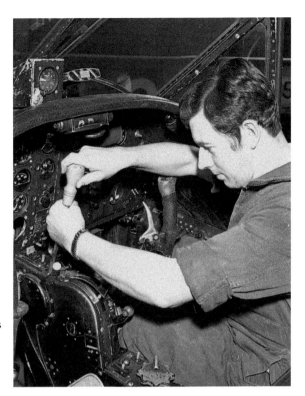

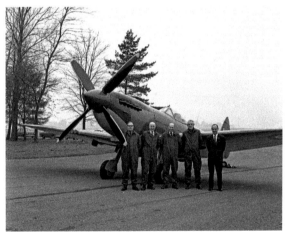

Spitfire refurbished at No 5 MU, *c.* 1969.

Red Arrows Flight Leaving RAF Kemble for the Last Time, 1983

The Red Arrows provided a regular spectacle over the Cirencester skies during their twice-daily practices. Sadly not all the practice flights were joyous and between 1969 and 1971, five aircraft crashed and a total of five pilots lost their lives at or near the Kemble runway. (W&GS)

Places of Worship

Congregational Church

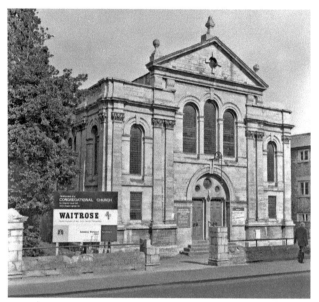

Congregational Church for Sale, 1970

It is said that the demolition of the Congregational Church in Dyer Street in 1972 was done without planning permission, but this is hard to prove. What is known, however, is that where the 1970's 'modern' shopping block now stands, containing Argos and Savers (selling discounted goods), there was once an Italianate-style church that housed many popular organisations and served a local community and a church congregation. (W&GS)

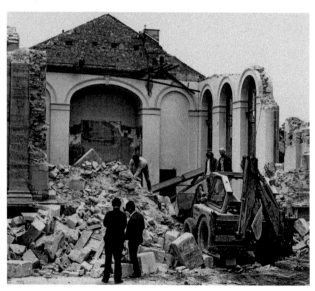

The Congregational Church was demolished in 1972 and replaced by the first Waitrose supermarket in Ciren. The church had seating for 537 people and had eight classrooms at the rear of the building where it hosted a number of organisations such as 'The Boys Brigade', which were founded in the 1880s around the time that the Congregational Church was constructed in Dyer Street. (W&GS)

Salvation Army

Salvation Army Hall (Demolished in 2019)

The Salvation Army Hall on the corner of Church Street was meant to be temporary accommodation for the church. It was built in 1926 from wood and asbestos but was used until 1977 when the Salvation Army moved back to its original home at the temperance hall in Thomas Street.

Baptist Church

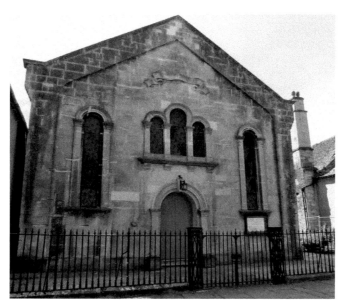

Baptist Church, Coxwell Street

This church was built in 1856/7 and replaced an earlier chapel of *c.* 1650. The church was vacated by the congregation several years prior to its sale in 2017 due to no longer being suitable for an ever-increasing congregation. It was recently converted to housing in 2019.

The Baptists met at the Deer Park School for several years where they had room for a congregation that reputedly exceeded a thousand people. This was merely temporary and the Baptist Church used the money from the sale of the Coxwell Street building to part fund its new premises at Love Lane. This was the former NAAFI bakery and had in recent years has been a social club, which had been known as the Chesterton Suite.

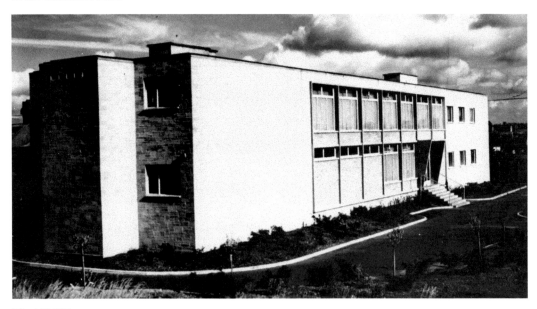

The NAAFI

The NAAFI (Navy, Army Airforce Institutes) were formed in 1921 as a cooperative business run by the services. It was said to be the biggest pantry in the world at the start of the Second World War. As caterer to the armed forces until it closed in 1997, the NAAFI had supplied stewed vegetables, tough pork chops and bromide tea to our fighting men and women for seventy-five years. The Cirencester NAAFI was just a bakery unit and employed many local people.

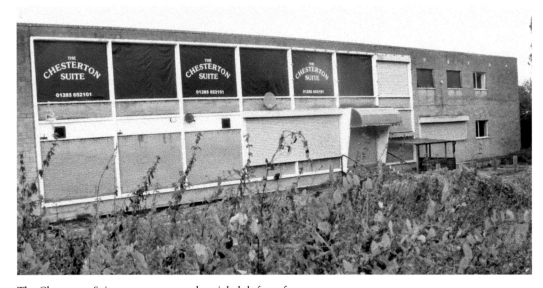

The Chesterton Suite was a sports and social club for a few years.

Unitarian Church

Unitarian Chapel, 1992

The Unitarian Chapel, approached through an archway in Gosditch Street, is the oldest nonconformist chapel in town, having been erected as a Presbyterian chapel in 1648. In common with other nonconformist faiths, the chapel has a burial ground at a the rear.

Burial ground at rear, 1992. (W&GS)

The Chapel, 1992

Regular services in the Gosditch Street chapel ceased in 1969 and the chapel became the Parish Centre for the Church of England. It was sold for £175,000 for redevelopment in 2017.

The Friends Meeting House

The Friends Meeting House (Quakers) in Thomas Street is one of the oldest in the country, dating from 1673, and while it is not 'lost', regular meetings ceased in 1922 and the building was used as a labour exchange from 1926 to 1947. Quaker meetings resumed in 1949.

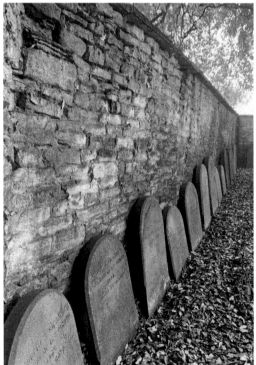

Quaker Burial Ground, Thomas Street

The burial ground behind the meeting house was relandscaped as a garden after the First World War by six German prisoners of war, when the headstones (mainly late nineteenth century) were moved to the perimeter wall. The earliest interment was in 1673 (Thomas Barnfield). Others buried here include Giles Fettiplace, son of the Civil Governor of the Parliamentarian garrison, who led the unsuccessful defence of Cirencester against Prince Rupert's Royalists on 2 February 1643 and members of the Bowly family, prominent in local affairs over many generations. The garden is still used for the scattering of ashes.

Rear garden of the meeting house, formerly a burial area.

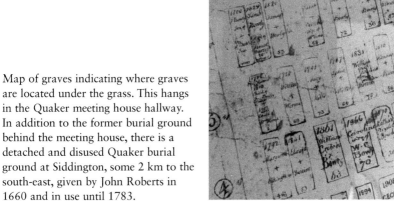

Map of graves indicating where graves are located under the grass. This hangs in the Quaker meeting house hallway. In addition to the former burial ground behind the meeting house, there is a detached and disused Quaker burial ground at Siddington, some 2 km to the south-east, given by John Roberts in 1660 and in use until 1783.

Houses

In the last 100 years, Cirencester has lost many buildings and bits of land that have been built upon or put to other purposes. These include several large houses that once graced the town.

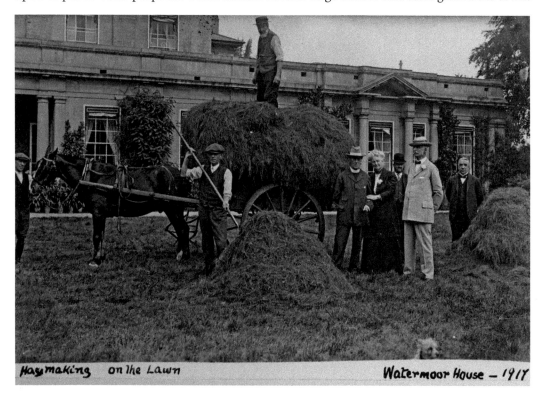

Haymaking on the Lawn Watermoor House – 1917

Watermoor House

Haymaking on the lawn of Watermoor House with owner Sir Thomas Kingscote in 1917. Watermoor House was built in 1825–27 for the solicitor Joseph Randolph Mullings by William Jay of Cheltenham and was a three by four bay, two-storey ashlar villa. Sometime before 1835 a large, higher addition was made to the north. Mullings let Watermoor to Admiral Sir Richard Talbot from 1842, who bought it in 1854 and extended the grounds to around 12 acres. Thomas Kingscote acquired Watermoor and V.A. Lawson designed extensions in 1908, including a chapel and a ballroom. The Gloucestershire Old People's Housing Society bought it in 1952. (Corinium Museum)

Chesterton House

Charles Brooke, known as the White Rajah of Sarawak, bought Chesterton House in 1902 (now a residential care home). He spent part of every year there and had many local interests including fox hunting (which in 1912 cost him his sight in one eye) and bird breeding. Brooke died of hypostatic pneumonia at Chesterton House on 17 May 1917. His body was embalmed for later burial in Sarawak and placed in a mausoleum, then in 1919 was buried near his uncle, James Brooke, the first Rajah, at Sheepstor Devon.

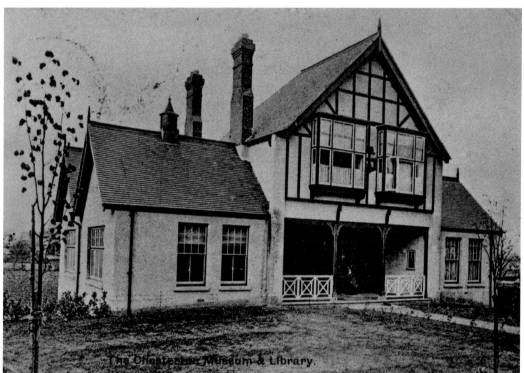

Chesterton Library/Museum

Built by the White Rajah of Sarawak *c.* 1903, this building held a great many curiosities including a stuffed snake in the act of swallowing a pig. Charles Brooke had many interests and the collection mirrored this. It was open to the public two afternoons a week. It's not known what happened to the collection when Brooke died. The last time this building was used was as the school and gym of Our Lady's Convent. (W&GS)

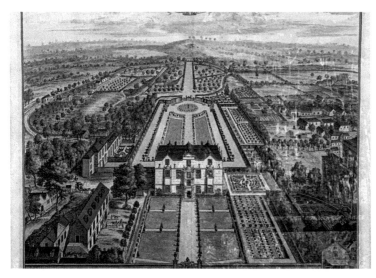

Johannes Kip,
'the Abbey of
Cirencester', 1712.

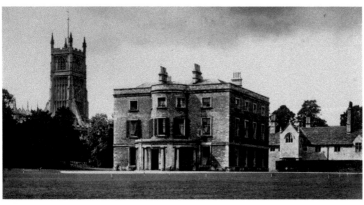

Abbey House
Abbey House in
1903. (Tait)

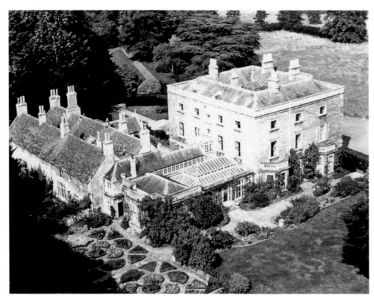

Abbey House, 1960s.

Hospitals

Union Workhouse/Watermoor Hospital

Workhouse before Conversion

In terms of what has been lost in the last century, much has changed in terms of Cirencester hospitals. The Union Workhouse/ Watermoor Hospital and the Memorial Hospital no longer exist in their original form. The former workhouse building was in use as Watermoor Hospital in 1971 and by 2005 had been converted into Cotswold District Council offices. (W&GS)

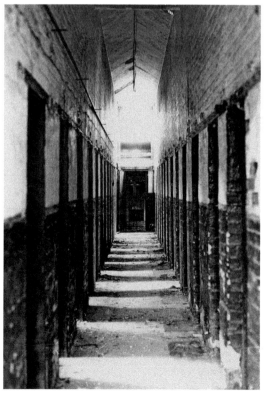

One of the corridors in the workhouse.

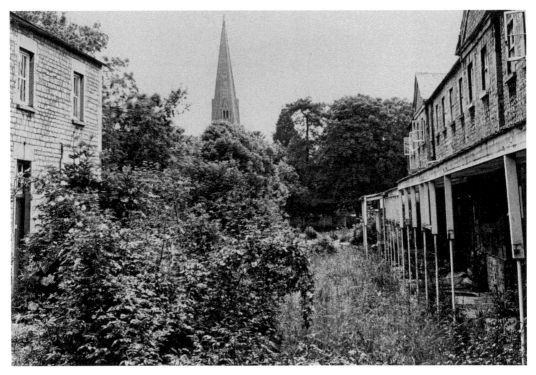

Workhouse courtyard with Watermoor Church spire in the background. (W&GS)

Memorial Hospital

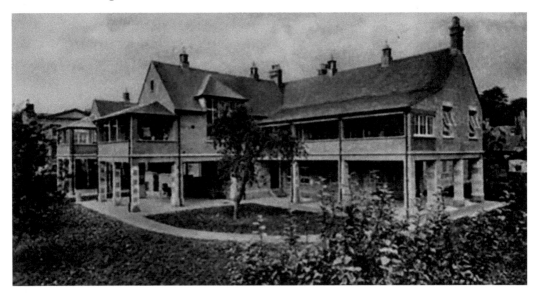

Established in 1875 as the Cottage Hospital, the Memorial, as it later became known, ceased being used as a hospital in 1990 and was used as a registry office for a while. It fell into disrepair and was finally demolished in early 2020 to make way for parking spaces. It was a true community hospital and much missed by those who once used it. The image shows the hospital in 1900.

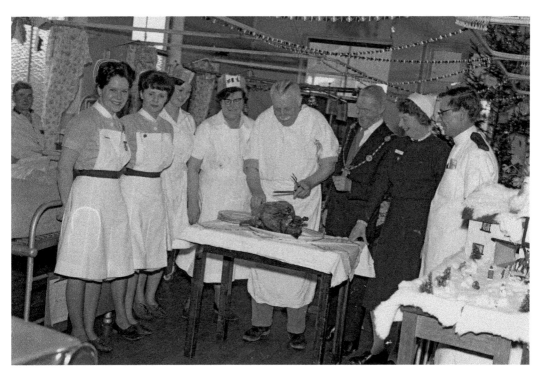

A surgeon carves a turkey in 1966. (W&GS)

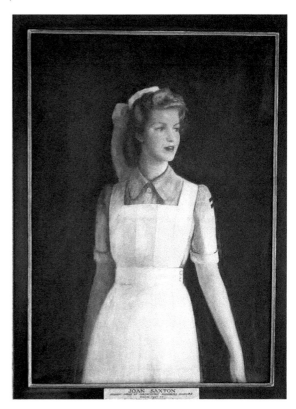

Nurse Saxton, 1946. (Saxton)

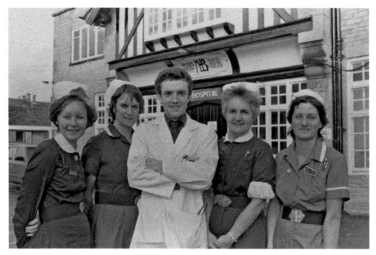

Hospital staff in 1984.
(W&GS)

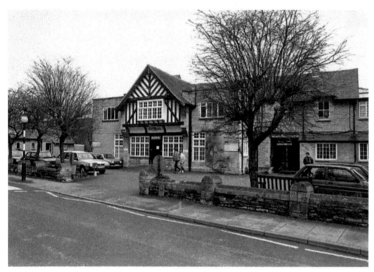

The hospital in 1988.

Memorial Hospital
in 2019.

Frank Cadogan-Cowper RA

Frank Cadogan Cowper was a Royal Academician who exhibited at the Royal Academy for over fifty years. He was described as 'The last of the Pre-Raphaelites' working in both watercolours and oils. Cowper lived most of his life in London but spent his later years in Cirencester at his studio Somerton, Berkley Road, Cirencester. (NPG)

Nurse Joan Saxton

Cowper was recovering at Cirencester after an operation in 1946 and he painted student nurse Joan Saxton during his stay. He later donated the portrait to the hospital. It now hangs in the new Cirencester Hospital. Joan trained at the hospital for three years before qualifying as a Senior Registered Nurse in 1949 (see earlier picture). He died at the Memorial Hospital on 17 November 1958 and is buried at Chesterton.

Places

Factories

In the last half century industry in Cirencester has continued to follow a trend, whether it be agricultural implements, ticket machines, plastic baths in different shapes and colours (P&S Plastics, Love Lane) or electronics (Mycalex, Ashcroft Road).

Cole & Lewis Bacon Factory, 1960

Cole & Lewis Bacon Curers Cotswold Bacon Factory existed from 1877 until the 1960s. The factory was where Martin's Close at Chesterton is now and was a few minutes' walk from Chesterton Halt railway stop. Cole and Lewis specialised in "Bath Chaps" i.e pigs cheeks cooked and coated in breadcrumbs.

ADDO Factory, Love Lane, 1960s.

Telephone Exchanges

Jane Townsend, Telephone Exchange Operator, 1966

It's sometimes hard to remember the days before mobile telephones or even further back when few people had a telephone line connected to their house with a single phone fitted near to the line entry point – usually in the hallway. For those that didn't have this facility, there were phone boxes in town and on the estates. The Beeches had three in the 1960s. Cirencester adopted Subscriber Trunk Dialling (STD) in 1966 and went digital in 1988. Manned exchanges became redundant.

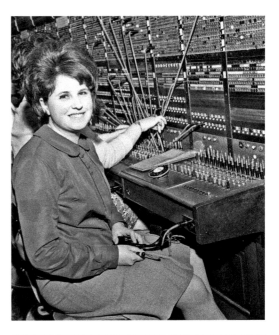

Guest Houses

The Arkenside Hotel was a Victorian building built in 1859 in Regency style. It was situated next to the Regal cinema at Nos 44–46 Lewis Lane. The hotel was removed in 2006 when the main building was taken down and recycled, but the façade was dismantled brick by brick to be sold and rebuilt exactly as it stands today at a private residence in Horsham, Sussex.

The façade stored on pallets awaiting sale in 2007. (W&GS)

Arkenside today (with Bingham Close in the distance). This is the building that replaced the Regal cinema on that site. Other guest houses now lost include the Riverside Guest House, Beeches Road, which was redeveloped as part of the ring road and is now residential flats. (Ciren Pool)

Cattle Market

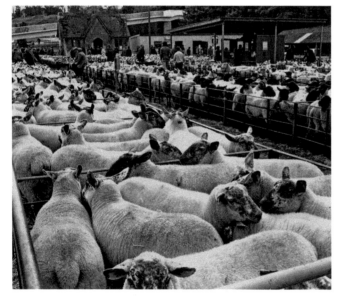

Cattle Market, 1986

Cirencester's wealth was built on wool, evidence of which can be easily found in town. Just down Dyer Street where the Cirencester Garage once stood (see photo earlier) an entire precinct replaced the garage in 1980, which was aptly named the Woolmarket. A large bronze ram stands at the entrance where there were once petrol pumps. There used to be real sheep in Cirencester at the regular livestock markets off Tetbury Road. This has long gone and it's hard to see where the market once used to be. (W&GS)

Amusements

The Gaumont

Gaumont Cinema, 1930s

In the 1940s and 1950s if you wanted to see to see a film, or as we said then 'go to the flicks', you had a choice of two cinemas in Cirencester: the Gaumont on the corner of Victoria Road and London road, opened in 1924 as the Picture House, or the Regal cinema in Lewes Lane. The Gaumont was sold in 1963 and demolished to make way for the flats that stand on the site today.

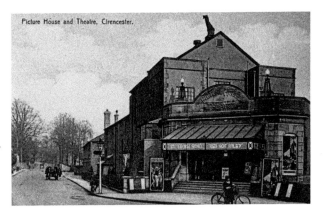

Mr McRae, Regal cinema manager, 1966. (W&GS)

The Regal Cinema

The Regal, which opened in 1937, was bigger than the Gaumont and not only had a wider proscenium and a 12-foot-deep stage, but it also had two dressing rooms for visiting entertainers.

The Regal provided a wide range of entertainment and as well as films, there were regular events along the same lines as those at the burgeoning Holiday Camps such as 'Glamorous Grandmother' Competitions and pancake tossing.

The Gaumont closed around 1963 to make way for the flats that stand in its place now. The Regal closed in 1977 and was demolished in 2007.

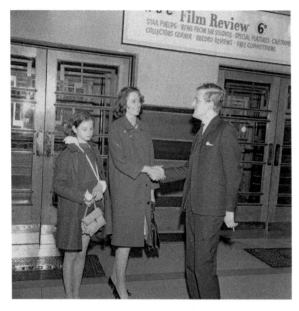

A visit to the cinema was met with a welcome from the manager. (W&GS)

Pancake Tossing Competition, 1967

The Regal was more than just a cinema. It held competitions and events with the Lewis Lane School, which was opposite on Lewis Lane. Carnival Queen selections took place at the Regal. Perhaps the most singular thing that many people remember about the Regal is the Saturday morning club for children, which was called the ABC Minors. (W&GS)

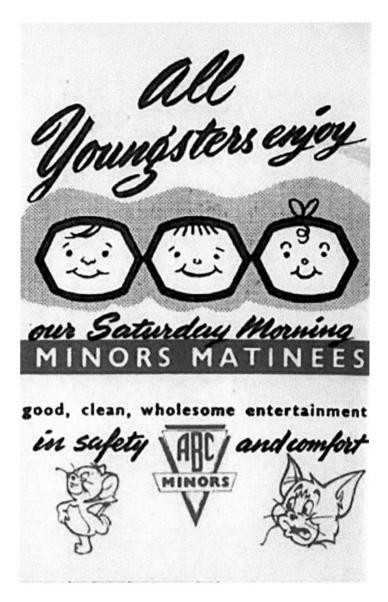

ABC Minors Advert.

The ABC Minors song, to the tune of 'Blaze Away', had the words projected onto the screen with a small bouncing ball that highlighted each word.

We are the boys and girls well known as Minors of the ABC,
And every Saturday we line up,
To see the films we like,
And shout aloud with glee,
We love to laugh and have a singsong,
Such a happy crowd are we,
We're all pals together,
The minors of the ABC

ABC Minors win prizes and
birthdays are remembered by staff in
the 1960s.

Lewis Lane School pupils on 1966. The school was opposite. (W&GS)

Open-air Pool

While the open-air pool was nearly lost and it fell derelict for a time in the 1970s, it was rescued by a team of volunteers and is now a successful enterprise. What does remain lost are the diving and underwater length swimming competitions. Galas and water polo matches were once held at the pool to enthusiastic crowds and spectators. The Ciren Pool is now the UK's oldest open-air pool, having been in continual use every summer since 1869. Although there are one or two other slightly older pools, they have not always remained open. In fact 90 per cent of all the UK's pools have been demolished in the last forty years. It has been run by volunteers since 1973 and is now a registered charity.

There used to be several places to swim in Cirencester other than the open-air pool in the summer. Siddington School once had a semi-permanent pool that stood in the grounds and Deer Park School had a proper swimming pool built alongside the main building at the time. Many people swam at the Gravel Pits at South Cerney.

Pool opening in 1931.

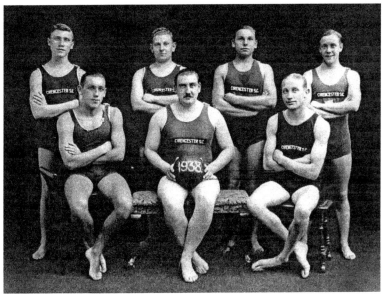

Water polo team in 1938.

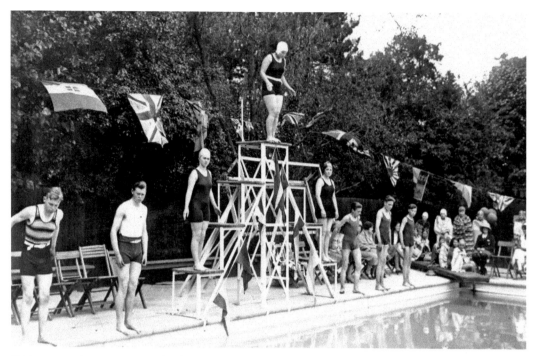

Diving competitions were a regular feature. The deep end of the pool was slightly deeper than at present in these times. Since the 1960s, however, I remember it being 6 feet deep with a springboard and a high board. (Ciren Pool)

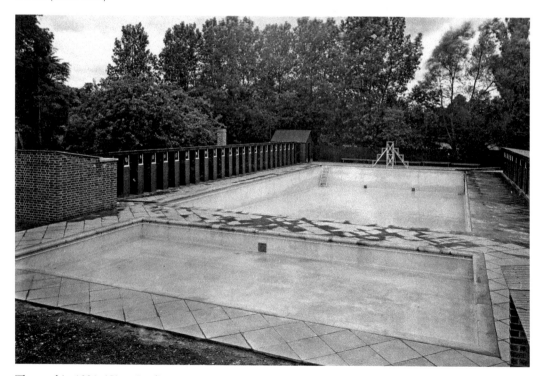

The pool in 1931. (Ciren Pool)

Carnival

Carnival Procession, Dyer Street

For many years, and certainly within living memory, the Cirencester Carnival was the main annual social and civic event in Ciren. It took place every July and it was eagerly anticipated by people in Cirencester and the surrounding area. Leading up to the event, which always took place on a Saturday, there were many associated events and activities that took place, including the building of processional floats and making of fancy dress outfits. (W&GS)

Spectators Watching the Procession in Market Place, 1974

On the day thousands lined the Cirencester streets to watch as the procession passed by, travelling from the park gates at Cecily Hill through town and Market Place to eventually arrive at the carnival ground. (W&GS)

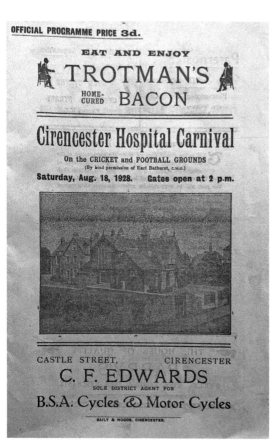

OFFICIAL PROGRAMME PRICE 3d.

EAT AND ENJOY

TROTMAN'S

HOME-CURED BACON

Cirencester Hospital Carnival

On the CRICKET and FOOTBALL GROUNDS
(By kind permission of Earl Bathurst, C.M.G.)

Saturday, Aug. 18, 1928. Gates open at 2 p.m.

CASTLE STREET, CIRENCESTER

C. F. EDWARDS

SOLE DISTRICT AGENT FOR

B.S.A. Cycles & Motor Cycles

BAILY & WOODS, CIRENCESTER.

Carnival Programme, 1928

First established by the Friendly Societies around 1898 as a continuation from the annual Church Parades and collections for the parish church, the carnival became linked to the Memorial Hospital, being known for the first time as the 'Hospital Carnival'. The name continued until at least until 1947 when the name Cirencester Hospital Carnival was dropped for simply Cirencester Carnival. The reason appears to have been financial as the committee reports from 1946 report apathy from the public who were aggrieved at contributing towards the hospital when they were already paying 7s 1d a week to the National Health Service.

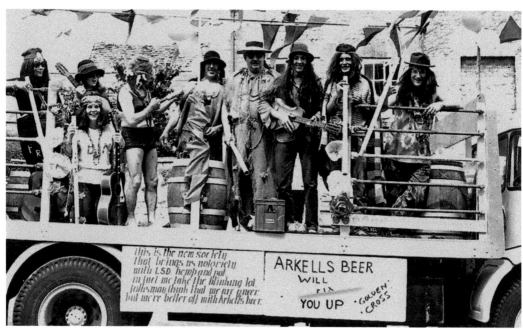

Carnival float, Golden Cross Pub, 1977. (W&GS)

Carnival Programme, 1928

The committee decided that it wasn't enough anymore to simply have attractions such as a man diving 60 feet into a wet sponge or a 'slyest looking mongrel'. What was needed were events that would foster greater interest and social participation.

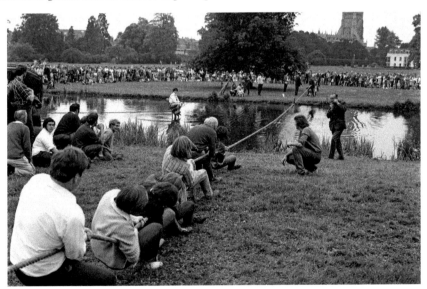

Tug of War over the Abbey Lake, 1971

From then on, events such as pram races and a tug of war across the abbey lake took place. Band competitions also began around this time with a new silver cup introduced in 1948 to copy the one that had already been adopted at the nearby Fairford Carnival. In the 1960s a 'smash a piano competition' was introduced, an activity that was hugely popular at the time and eventually became a fad in the USA. The Guinness Book of Records even had a record for the fastest time to destroy an upright piano with sledgehammers and pass the parts through a 9-inch diameter hole. (W&GS)

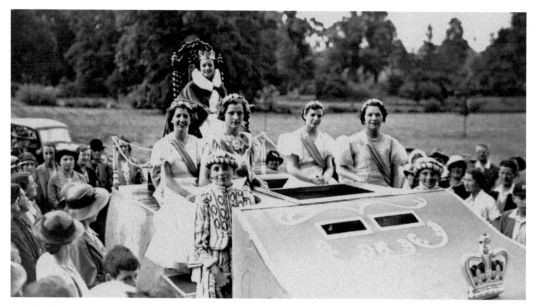

Carnival Queen, 1953

One of the most highly contested competitions each year was for the title of Carnival Queen – chosen from sometimes hundreds of local young women. The Queen would be processed around the town with her attendants and would preside over the competitions and present cups and awards to the winners. Over the years things changed and 'Queen' became 'Fairy Princess' and at its closure in 1997 also had young boys as 'Princes'. (W&GS)

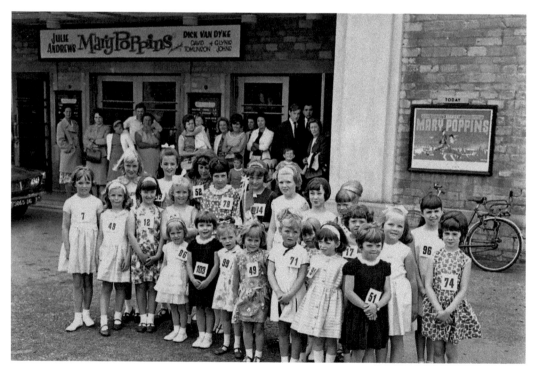

Carnival Princess final at the Regal cinema in 1966. (W&GS)

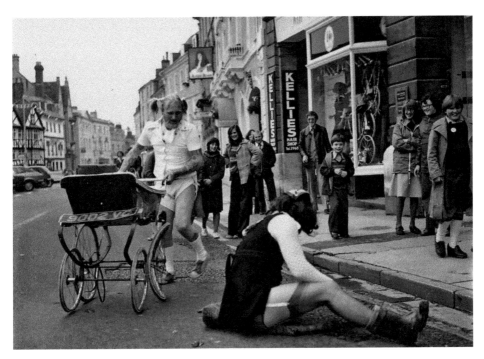

Pram Racing, 1966

Sports competitions were an important part of the carnival and silver cups were awarded to winning teams. Little is known of what happened to the cups after the carnival ended in 1997. (W&GS)

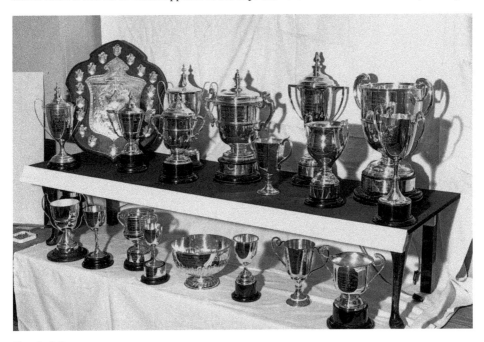

Carnival Cups

The lost carnival cups, seen here all together in 1965. The whereabouts of the cups today is unknown. (W&GS)

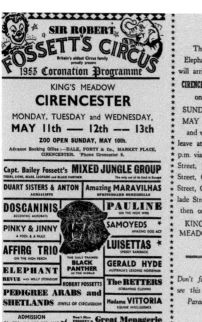

Circus Poster, 1953

Today's circus is very different to those that visited the town before the days of greater animal welfare and strict health and safety regulations. Before all this circuses regularly brought wild animals to Cirencester and it was not uncommon in the 1970s and 1980s to see lions, tigers, camels and elephants next to the swings and slide at City Bank.

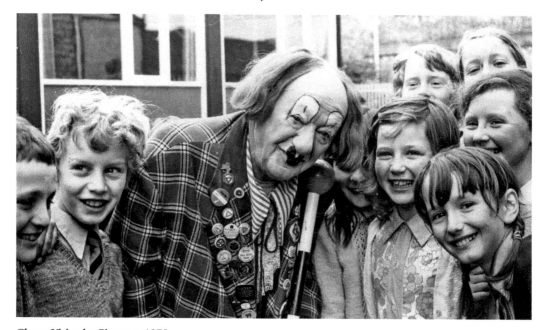

Clown Visits the Circus, *c.* 1975

The 1879 *Wilts & Glos Standard* reported wild animals at the circus, but also people in the form of 'representatives of our foes ... imported from Zululand'. The warriors were displayed at Mr Coxe's field at New Road (later renamed Victoria Road) and anyone acquainted with the Zulu language was invited to interrogate the chief or any of the tribe. Spectators were also given a demonstration of throwing the Assegai. (W&GS)

Dancing

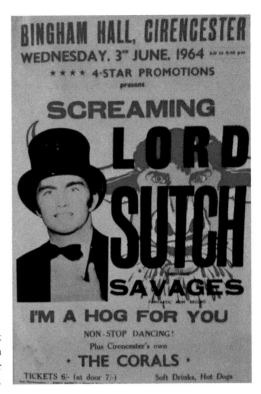

Concert Poster for Screaming Lord Sutch at Bingham Hall in 1964. Dances have taken place at the Corn Hall from the time it opened in late 1862, with the first dance being the V. W. H. Hunt Ball on 21 January 1863. When Bingham Hall opened in 1908 it was also a venue for dancing and concerts.

In the early years, dancing was mostly a black tie event and several formal balls were held each year, including the V. W. H. Ball and the Cirencester Ball, which was at first called the Bachelor's Ball'.

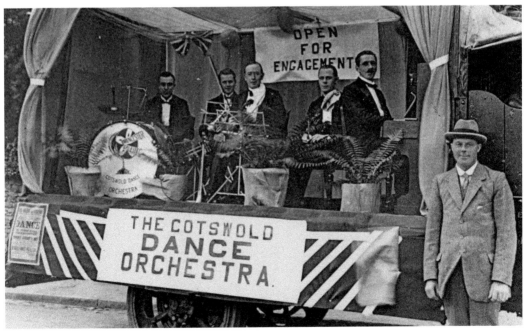

Cotswold Dance Orchestra were a countrywide touring band.

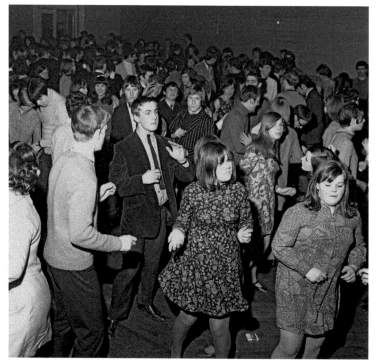

Stax Club Opens

Many bands and small orchestras have played at the Corn Hall, but for many the Stax Club of the 1960s, which had live soul music bands, remains a fond memory for many Cirencester people. In 1967 when the Stax Club opened it was 7 shillings and 6 pence to get in back then, and beer was half a crown a pint (12.5 pence). (W&GS)

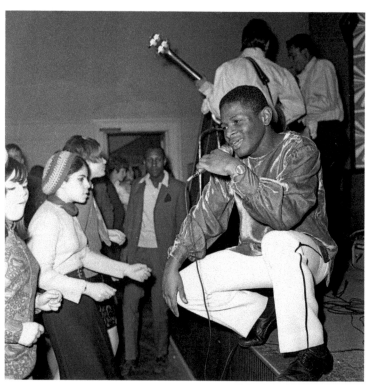

Stax Club Opens

Many popular soul bands played at the Stax Club in the short three years it ran. These included top bands such as Gino Washington and the Ram Jam band. On 6 April 1968 (shown here), Desmond Decker, The Pyramids Jnr Walker and the All Stars played here, who also gave a concert at Bingham Hall in 1970. (W&GS)

Country Dancing

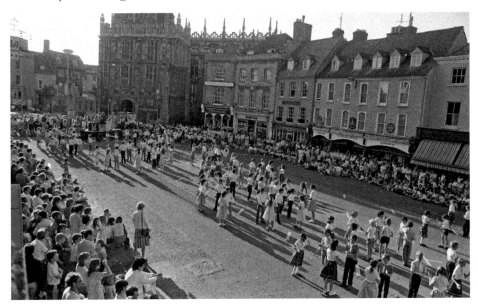

Country Dance Festival, 1986

Many schools in the 1950s and 1960s had country dancing as part of the school curriculum. Interest was first fostered at infants' schools with Music and Movement presented on BBC radio, which went out most mornings, except Mondays, when at 11a.m. there was 'Singing Together' with William Appleby.

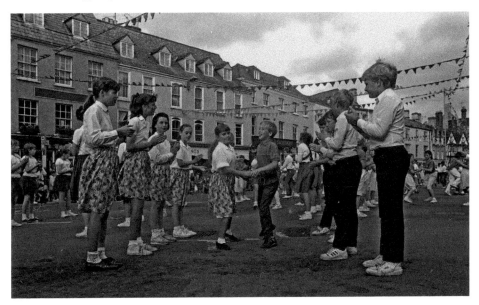

Country Dance Festival, 1990

The Music and Movement activities fostered an interest in country dancing for many pupils and one of the highlights of the school year was the annual Country Dancing Festival held either in Market Place or in later years on the sports field at the Deer Park School. (W&GS)

Social

Cirencester has always had teams, clubs and organisations to suit the individuals and social groups who live in and around the town. There were eighty-four listed in 1940 and more recently the Cirencester town website currently lists fifty-nine. Times change and interest wanes: the Pipe Smoking Club, the Quoit Club and the Amateur Wine Makers Club have all now gone from the town.

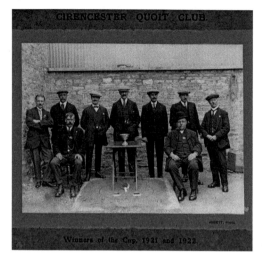

Cirencester Quoit Throwing Club were cup winners in 1922 and 1923. (W&GS)

Fraternal Societies

The Royal Antediluvian Order of Buffaloes (aka Buffs) continue in Cirencester, with one lodge where it once had five. The lodge furniture, fixtures and fittings for the lost lodges were recently auctioned in Cirencester (2020) and raised less than £500. Independent Order of Odd Fellows in its heyday had two lodges in Cirencester. The nearest lodge to Cirencester is now Ross-on-Wye. The Independent Order of Forresters once had a large prescence with two 'Courts'.

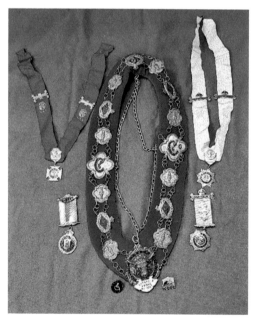

RAOB Regalia (Railway Lodge) auctioned in 2020.

Phoenix Majorettes

The Cirencester Phoenix Majorettes were formed in 1975 by Judith Wood to help celebrate Cirencester's Heritage Year. The girls were either members of Cirencester Community Centre or Cirencester Ballet Club, and aged from eight to sixteen years. The troupe entered many majorette competitions in the south-west of England over the twenty-five years and became successful, winning many cups, trophies and medals. The troupe was disbanded in 2000 just after becoming the Overall Champions of the South West of England.

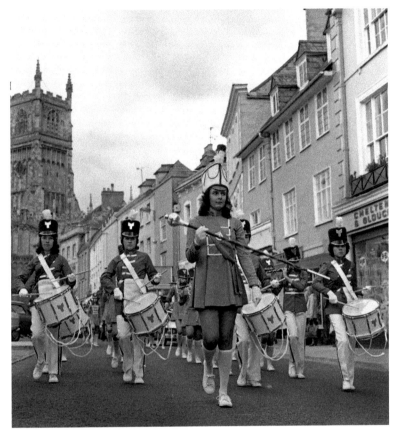

Majorettes, 1979. (W&GS)

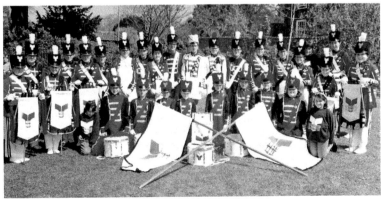

Majorettes. (W&GS)

Local Characters

History records the rich and famous but there have been other people and families in Cirencester who were less famous but have nonetheless held a place in the hearts of Cirencester folk.

Herbert Stark (1906–76)

It's fair to say that Herbert Stark was a true English eccentric who, rumour had it, was very rich but lived an alternative lifestyle. In the 1970s he was a well-known figure around town and is still remembered to this day for his appearance and his benign nature. The archetypal hobo in appearance, he wore a scruffy black suit, always with a flower in his lapel, and a dishevelled hat.

Many stories are attributed to 'Starky', as he was affectionately known, some apocryphal and many based on reality. It was said that he was an orphan adopted by the Roundtree family in York, joined the RAF and became a batman to Dambusters – Sir Leonard Cheshire V.C. He was also said to have performed a similar role for Winston Churchill's nephew.

Starky was very much a local celebrity in his time. He attended most funerals in town (and weddings) – invited or not. He was a regular exhibitor of flowers at local shows and he kept prize-winning cats that he also exhibited. He entered the Cirencester Carnival every year with his decorated butcher's bike. Born Yorkshire, he died at Swindon Hospital and was buried at Chesterton.

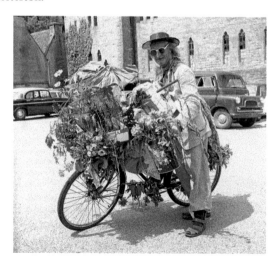 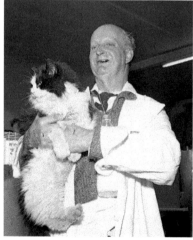

Herbert Stark at the carnival in 1977. He decorated his bike every year for the carnival. (W&GS)

Percy Herbert Pooley (1886–1971)

Percy Pooley was well known in Cirencester for his work with the British Brotherhood of Boy Scouts from 1926 until 1971. Percy Pooley joined as a scoutmaster in 1911, becoming the chief commissioner in 1926. He became Chief Commissioner of the British Brotherhood of Boy Scouts. He died in Lydbrook Hospital, Gloucestershire, aged eighty-five, and was buried in plot 26/r5 on 10 September 1971 at Chesterton.

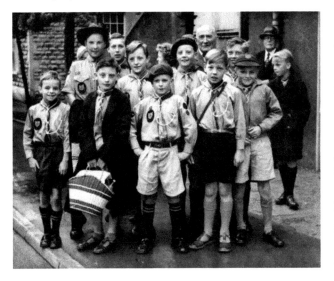

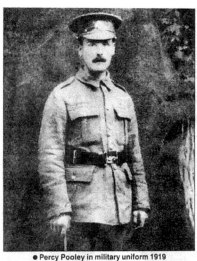

● Percy Pooley in military uniform 1919

Arthur Henry Gibbons (1863–1944)

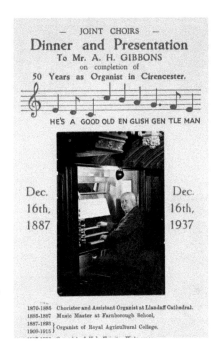

Arthur Gibbons was an organist and choirmaster for fifty-seven years from 1896 at Cirencester Parish Church, from 1887 to 1896 organist and choirmaster at Holy Trinity Church, Watermoor, Cirencester. He was also organist at the Royal Agricultural College for two periods (1887–93 and 1909–15). A commemorative tablet is placed in the chancel on the wall adjoining the organ at the parish church.

Mary Ann Gibbons

Mary Ann Gibbons was the mother of Arthur Henry Gibbons and seven other children. Three of her sons were artists, two of which were particularly influential in the English Aesthetic Movement. Owen Gibbons (1847–1911) and Francis Gibbons (1853–1918) designed polychrome ceramic tiles for Maw & Co., which by the end of the century was the largest tile factory in the world, producing art nouveau designs, followed by unique art deco geometric styles.

When Mary Ann Gibbons died in 1863, she was buried in Chesterton Cemetery in a grave that even today stands out as being highly unusual. The grave, provided by her sons, is a highly decorated monument covered with majolica-style tiles produced at the Maw & Co. factory. The tiles burst with lilies suggesting peace and flawlessness, and also roses, which symbolise love and also hint at a secret – perhaps the secret being one the brothers wanted to keep. Mary Ann Gibbons died 'insane' in Gloucester Asylum.

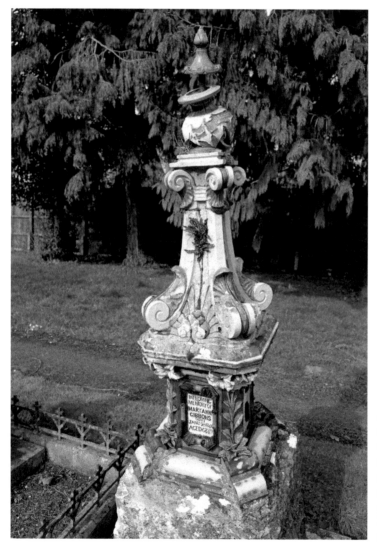

Grave at the Chesterton Cemetery for Mary Ann Gibbons, an unusual memorial quite unlike anything else in the cemetery. It is falling apart and will soon be a 'lost' memorial to the past.

Colin Flukes (aka Cosy Powell, 1947–98)

Colin played as a drummer for a time with the local group the Corals before he achieved international success with bands such as The Jeff Beck Group; Whitesnake; Emerson, Lake and Palmer; and Black Sabbath. Cozy Powell met an untimely death at the age of just fifty and is remembered in the town with a blue plaque on the Corn Hall, commemorating his playing there with the Corals.

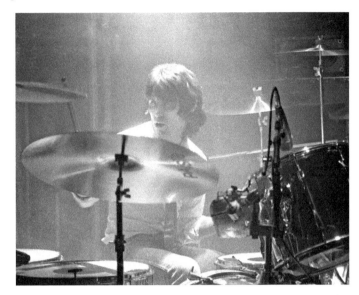

Cozy Powell in action. (W&GS)

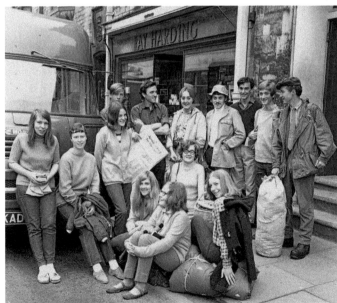

Above left: Adam's Pad sign.

Above right: Adam's Pad folk: 'The Herd' about to embark on a camping holiday together. (W&GS)

Many of the Herd members had artistic abilities and as a result Adam's Pad was highly decorated in 1960s 'pop art' style with wall murals and their names stencilled in large type face on the kitchen wall.

Revd Adam Ford and the 'Herd', 1968

Adam Ford was a curate in the town for a relatively short period in the 1960s, but during that time he was a support to many teenagers, disaffected and otherwise. Adam Ford provided a different sort of 'home from home' to his parish at No. 53 Dyer Street, where music was played, meditation taught, and discussion of issues and feelings encouraged. Adam Ford led sponsored walks, silences and 'sit-ins' at a time in history overshadowed by the nuclear threat. He also formed the football team 'The Herd', which continued in the local league for many years after his departure.

Doctors

Back in the 1950s and 1960s, unlike today where there are around twenty-five GPs and five surgeries, there were just six GPs that covered the entire town. In these times when few people owned a telephone, you simply walked into the surgery and asked to see your personal doctor. You might have had to wait for a while in the waiting room, or be asked to come back later, but when you did, the doctor would greet you by name – and ask after your father and mother.

Dr Robert Edgar Hope-Simpson (1908–2003)

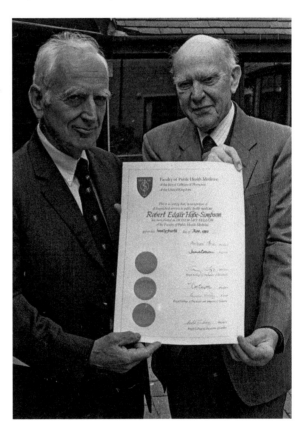

Dr Robert Edgar Hope-Simpson was made an honorary fellow in 1993. (W&GS)

Dr Robert Edgar Hope-Simpson, who lived in Cirencester from 1945 until he retired in 1976, trained as a doctor but was also a world-class medical researcher. It's said that Hope-Simpson probably made the most important clinical discovery in general practice in the twentieth century when he linked the shingles to the chickenpox virus. He also made major discoveries in the transmission of influenza.

Edgar's research activities, as well as a post as pathologist at Cirencester Memorial Hospital (1946–61) never stopped him practicing as a popular general practitioner (1946–76). He also had many other interests including active membership of the Society of Friends (Quakers) where, until shortly before his death in 2003, he could be found most Sunday mornings on the wooden benches at the Friend's Meeting House in Thomas Street.

Photographers

Weddings were once covered by the local press and printed in the next edition of the *Standard* and the *Echo*. No albums or prints were provided, but there are numerous photographers in Cirencester who did provide images: Peter Palmer (aka 'Potty Palmer'), George Roper, William Barrett and Fred Heaven. During wedding season the photographer would frequently rush off to one of the other churches, only to return later that day for another wedding.

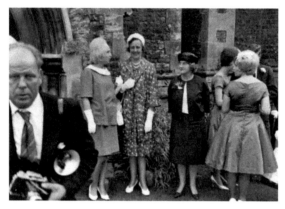

Fred Heaven, wedding photographer, 1960s.

Cirencester Schooldays

Schools and teachers are never forgotten – whether it was a good or bad experience. Cirencester has lost a number of schools in the last 100 years including Lewis Lane, The Convent, Ingleside, Grammar and the Secondary Moderns.

Lewis Lane School cap badge – a lost school.

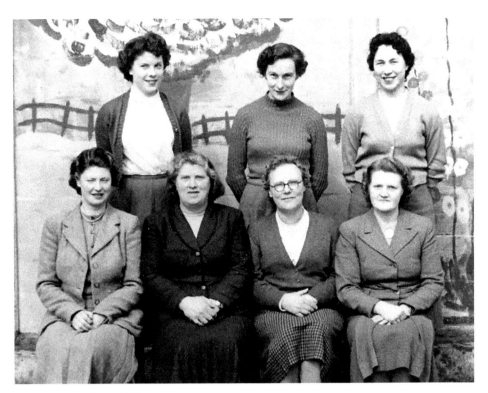

Lewis Lane teachers, 1950s.

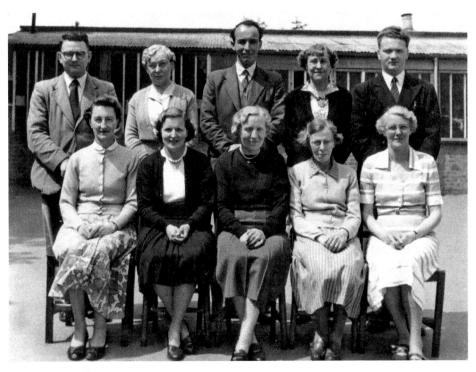

Lewis Lane teachers, 1962.

About the Author

Dr Robert Heaven JP DArt, MA, MSc, PG.Dip Psych is a social historian who was born and grew up in Cirencester in the 1950s and 1960s. He has postgraduate degrees in Art History (University of Sussex) and Victorian Studies (London University Birkbeck). He co-curated the Richard Redgrave RA exhibition at the Victoria and Albert Museum, London, and Yale University in 1988. Robert writes the weekly 'Nostalgia' page for the *Wilts & Glos Standard* and for various magazines and journals. He founded the social media group OldCiren in 2002 and continues to curate it.